WEAVERVILLE

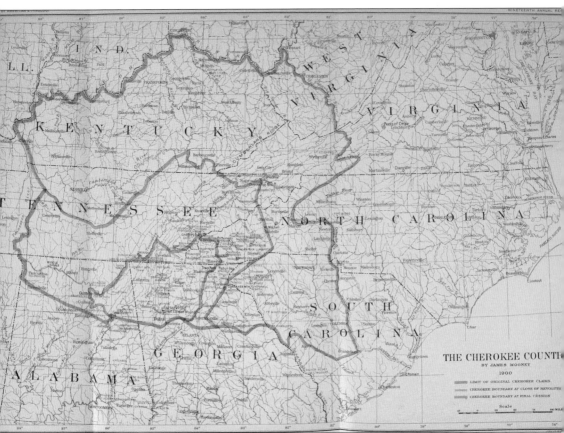

Present-day Weaverville would be just north of Asheville and east of Marshall on this map from James Mooney's *Myths of the Cherokee* (1902). Once known as Dry Ridge, the area was part of the original Cherokee land claims, located along the border of land still claimed by the Cherokee at the end of the Revolutionary War. The Treaty of Holston, signed in 1786, marked the beginning of white settlement in what had been Cherokee territory. (Courtesy of Dry Ridge Historical Museum.)

ON THE COVER: West Service Station was the first such facility north of Asheville in Buncombe County. As indicated on the station's roof, a traveler could even get tourist information about the young town of Weaverville. The station still stands today as Rodney's Auto Service. (Courtesy of Gary and Vicki West, West Family Funeral Services.)

IMAGES
of America

WEAVERVILLE

Tim W. Jackson and Taryn Chase Jackson

ARCADIA
PUBLISHING

Published by Arcadia Publishing
Charleston, South Carolina

Printed in the United States of America

Library of Congress Control Number: 2015933918

For all general information, please contact Arcadia Publishing:
Telephone 843-853-2070
Fax 843-853-0044
E-mail sales@arcadiapublishing.com
For customer service and orders:
Toll-Free 1-888-313-2665

Visit us on the Internet at www.arcadiapublishing.com

For all the past, present, and future residents of
Weaverville and its surrounding communities.

CONTENTS

ACKNOWLEDGMENTS

A thank you list for this book could certainly run long, as so many people contributed in one way or another. We should start with the Dry Ridge Historical Museum in Weaverville. Jan Lawrence and the rest of the museum's board and volunteer staff were of major assistance throughout this project. Larry Sprinkle, along with Gary and Vicki West, were instrumental to the project, offering photographs from their personal collections and providing information from their vantage point of multigenerational Weaverville families. We received photographs, too, from Lou Acorrnero, Bruce Hensley, Shelby Shields, Scott Shope, and Geraldine Ray.

Unless otherwise noted, all images appear courtesy of the Dry Ridge Historical Museum. We also had assistance from an array of archives, including University of North Carolina at Asheville, Pack Memorial Library, and the State Archives of North Carolina.

INTRODUCTION

The land now occupied by Weaverville was opened up to white settlers in a treaty with the Cherokee in 1792, although a few settlers had already begun to trickle into the Reems Creek area and what was preliminarily called Dry Ridge, later named Weaverville. Around that same time, Buncombe County was created from parts of Burke and Rutherford Counties. Prior to that, the Weaverville area was part of Burke County. The new Buncombe County encompassed a large part of Western North Carolina and was much larger than it is today.

These events occurred just a few years after the American Revolution. North Carolina was one of the 13 original colonies, but most of its population (393,751, according to the 1790 US Census) was in the eastern half of the state. The "West," which was basically anything west of North Carolina, was still mostly undiscovered wilderness. Consider that the population of Tennessee in 1790 was just 35,691. The Cherokee were fading from the landscape around Buncombe County, and white settlers were becoming more common.

According to Barbara Duncan, education director of the Museum of the Cherokee in Cherokee, North Carolina, "The Cherokees didn't interact that much with new settlers. They had a very structured government and they mostly interacted with European nations, their colonies, their representatives, and licensed traders. In this process they used many bilingual interpreters, sometimes the children of Scots/British traders and Cherokee women, sometimes Cherokees who had been captured or traveled and learned English." While legend has it that the area's name throughout most of the 1800s, Dry Ridge, came from the Cherokee, Duncan says she does not have definitive confirmation. She does say, however, that the Cherokee "easily conveyed their names for places to English speakers. Also Cherokees were expert map-makers, and put their names for places on many maps in the Colonial period."

Among those early settlers in 1787 were John Weaver and his wife, Elizabeth. The Weavers had five sons and six daughters. The eldest son, Jacob, is known as the patriarch and namesake of "the Tribe of Jacob," which has been gathering annually for family reunions for more than 100 years. Jacob and his wife, Elizabeth, had seven children. The youngest son of John and Elizabeth Weaver was Michael Montraville Weaver, who gave the land to create the town of Weaverville as well as Weaverville College.

Other early settlers included Col. David Vance Sr. and his wife, Mary Priscilla Brank, who moved to Reems Creek Valley sometime between 1785 and 1790. Their son David Jr. was father to Zebulon Baird Vance, one of the dominant politicians in North Carolina for several decades, including his term as governor during the Civil War. One of Asheville's most notable landmarks is the Vance Monument, located in the center of town. It was erected in 1896 to honor the late politician. Vance's maternal grandfather was Zebulon Baird, known as one of the founders of Asheville.

The Weavers, Vances, and Bairds, among others, were slaveholding families, so those surnames have long been associated with the area's African American residents, too. Much like the Tribe of Jacob, the Baird Family Reunion has been held annually for more than 100 years. It is one of the oldest continuous black family reunions in the state. Most multigenerational African American families in Weaverville still reside in the Hillside Community, on land once owned by the Bairds.

In the 1830s, the Salem Campground was a popular meeting place. A conference house was built in 1836 to host the Holston Annual Conference of the Methodist Church. The building was used as a school for several years. This first church was constructed on the camp ground and used until 1890, when a new Methodist church was built on Church Street.

The first post office was established on Reems Creek in 1850. The Blacksmer Masonic Lodge No. 170 was chartered in 1855. Schools and churches popped up as more settlers moved in. When Rev. Michael Montraville Weaver, youngest son of John Weaver, donated land to form a new village in what had been known as Dry Ridge, Weaverville was born. The town officially began in 1875 and had a splendid centennial celebration in 1975. Over the years, Weaverville has maintained its own identity. It has been erroneously called a bedroom community to Asheville. While it is true that many Weaverville residents work in Asheville, it is also true that many residents work in Weaverville or other nearby places. In recent years, it has become a popular area for retirees. Weaverville is less than 10 miles to downtown Asheville, but, in previous eras, that distance was still a long way to travel. So, Weaverville had its own businesses and culture.

In the early 1900s, the town began to flourish. The nearby Dula Springs Hotel and Blackberry Inn were popular resort areas that offered a respite to Lowcountry residents looking for cooler mountain air. A trolley between Weaverville and Asheville helped connect the two towns. More and more visitors began to experience Weaverville. In fact, famed author O. Henry lived here briefly in 1909 or 1910. In 1905, he was reacquainted with Sara Lindsay Coleman, a childhood sweetheart originally from Weaverville. They married in 1907 in Asheville. Sara later convinced him to move to Weaverville, where he could sober up and his health could improve. He apparently missed the hustle and bustle of New York, though, and moved back there, where he died on June 5, 1910.

Also in 1910, the town's predominant body of water, Lake Juanita, was renamed Lake Louise. The popular site had an impressive dance pavilion for a while. The town was developing a water system, and its residents were getting electricity. The growing downtown saw an interesting array of automobiles, along with horse-drawn vehicles and people on horseback. During World War I, the area saw many of its sons go into battle. Weaverville remained a small town, but it prospered through the 1920s. Like most of America, it felt the effects of the Great Depression in the 1930s. But the town rallied before war again took its toll on the community in the 1940s. In the 1950s, the area began to see more blue-collar jobs develop as industry moved into town. The Hadley Corporation, located down Reems Creek Road, provided jobs to many area residents and was known as a manufacturer of fine clothing. The town lived through segregation and the civil rights movement, and its centennial was followed a year later by the nation's bicentennial. Weaverville entered an era that might be considered more modern.

Weaverville itself retains much of its small-town charm, especially downtown. Charm would not be the word most would attach to Weaver Boulevard, which has become the home to fast-food restaurants, grocery stores, and chain discount stores, among other commercial enterprises. But downtown, residents still walk the sidewalks with their dogs and children, stopping to make small talk about the weather. The areas of Flat Creek and Reems Creek remain mostly rural—in fact, they get quite rural in a hurry. So, those wanting a bit more elbow room can live in Flat Creek or Reems Creek and still have a Weaverville postal address.

Residents, visitors, and descendents of Weaverville's earliest citizens will enjoy this look at Weaverville, Flat Creek, and Reems Creek over the years. It is hoped that the images will offer cherished insights or memories.

One

Settlers and Citizens

Reems Creek was home to several early Buncombe County officials, including the first court clerk, sheriff, and two of the first judges. In fact, Reems Creek resident David Vance Sr. was one of the men responsible for creating Buncombe County. The Vance family has a long history in the area. David Vance settled into Reems Creek Valley between 1785 and 1790, after serving in the Continental army and at Kings Mountain during the American Revolution and as a representative in the North Carolina General Assembly. He was a teacher, lawyer, and surveyor who acquired several acres of farm property in 1795. He was appointed clerk of court for Buncombe County and was elected colonel of the militia. His son Robert Brank Vance was a physician and US congressman. Yet another son, David Jr., was a merchant and farmer and a captain in the War of 1812. The first son of David Jr. was Robert B. Vance, a brigadier general in the Confederate army who served in the US Congress and the North Carolina House of Representatives. Another son was Zebulon Baird Vance.

John Weaver and his wife, Elizabeth Biffle, were also early settlers along Reems Creek, having crossed over the mountains from the Wautauga settlement around 1787. They had 11 children, thus beginning the Weaver lineage of the area. The oldest son was Jacob Weaver, whose family—the Tribe of Jacob—has been holding family reunions in the area for more than 100 years. Some of John Weaver's daughters married into families that were or became prominent in the area's early settlement, including the Vance, Pickens, and Garrison families. John Weaver's youngest son was Michael Montraville Weaver, whose donation of land created the town of Weaverville and Weaverville College. He married Jane Eliza Baird, and they had 11 children; two of their daughters married Reagans, another important surname in the early days of Weaverville.

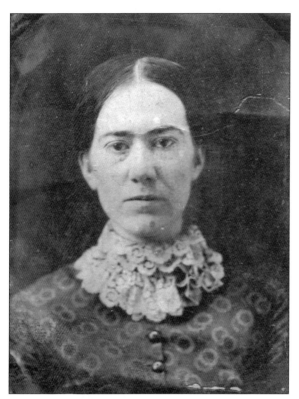

This tintype photograph shows Margaret Elizabeth "Lizzie" Weaver, the eldest daughter of William McKendree Weaver, granddaughter of Jacob Weaver, and great-granddaughter of John Weaver. She was born in 1851 and died in 1873, at just 21 years old. She was one of nine children born to William McKendree and Mary Evalyn Weaver.

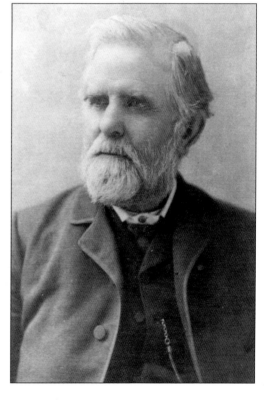

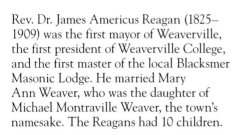

Rev. Dr. James Americus Reagan (1825–1909) was the first mayor of Weaverville, the first president of Weaverville College, and the first master of the local Blacksmer Masonic Lodge. He married Mary Ann Weaver, who was the daughter of Michael Montraville Weaver, the town's namesake. The Reagans had 10 children.

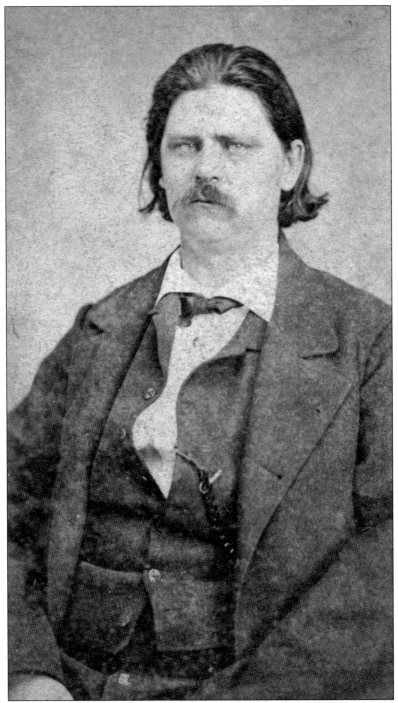

Zebulon Baird Vance (1830–1894) remains the area's most famous citizen. Son of David Vance Jr. and grandson of one of the area's first settlers, David Vance, Zebulon had a host of accomplishments, including terms as a North Carolina state representative (1854-1856), US representative (1856–1860), governor (1862–1865, 1877–1879), and US senator (1879–1894). (Courtesy of Pack Memorial Library.)

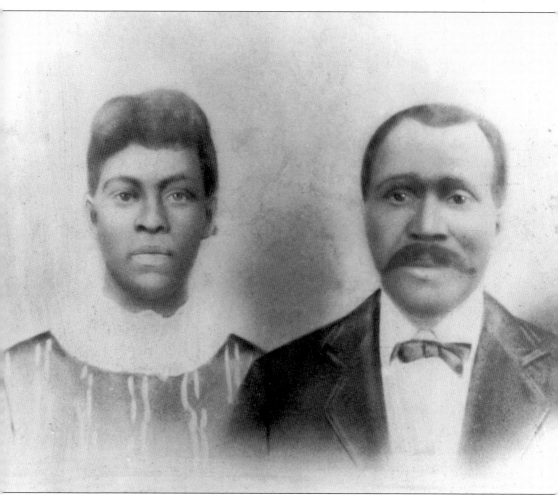

George (b. 1845) and Annie Weaver Bell (b. 1856) were longtime Flat Creek residents. They married in 1871 and had eight children. (Courtesy of Pack Memorial Library.)

Jane Eliza Baird Weaver (1810–1889) married Michael Montraville Weaver (1808–1882), the youngest son of John Weaver. The couple had 11 children.

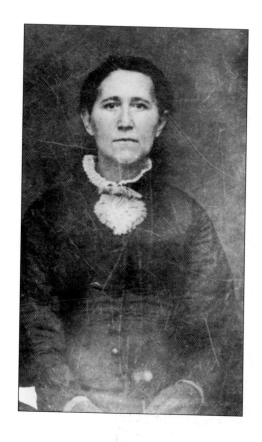

Elizabeth Siler Weaver (1788–1867) was the wife of Jacob Weaver (1786–1868), oldest son of John Weaver. The couple had nine children. Elizabeth is the matriarch of the Tribe of Jacob.

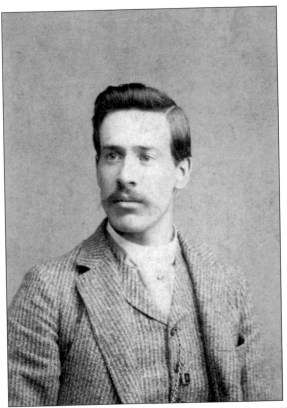

James Thomas Weaver was one of nine children born to Jacob and Elizabeth Siler Weaver. He was born in 1828 and died in Murfreesboro, Tennessee, in 1864, when he was a lieutenant colonel with the North Carolina Infantry Regiment as part of the Second Battle of Murfreesboro during the Civil War.

Pictured at right in the late 1800s is Mabel Clare Roberts (1887–1961), the daughter of Franklin Pierce and Susan Elizabeth Weaver Roberts. The girl at left is unidentified.

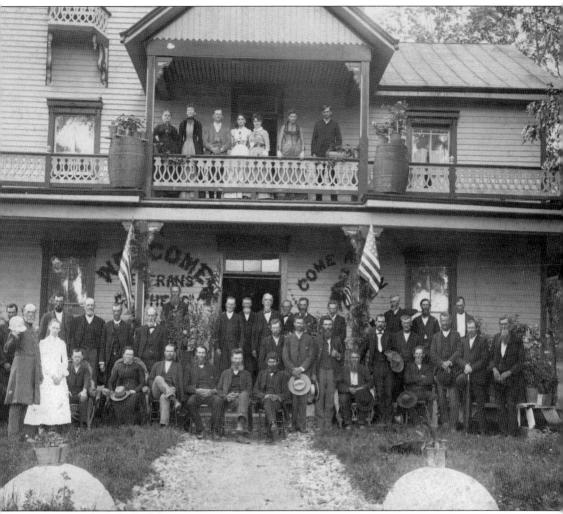

The Weaver family poses at a reunion on July 4, 1889. The photograph was taken at the Asheville home of Col. James Mitchell Ray, a Civil War veteran and half-brother of Forster Alexander Sondley, prominent attorney and historian.

Minnie Adelaide McElroy Reagan (1861–1921) was the wife of Dr. William Latta Reagan (1856–1911). William was the son of Dr. James Americus Reagan, one of the leading figures in the early days of Weaverville. The couple had five children.

According to the text on the back of this photograph, the persons shown here are, from left to right, (first row) Dr. William Latta Reagan (1856–1911), John Reagan, Bonnie Reagan, J. Roy Reagan, and Will Swain; (second row) Minnie McElroy Reagan, Mary Jo Reagan, Lydia Guthrie, and Vivian McElroy. Guthrie resided at this home. Vivian McElroy stayed with the Reagans and attended Weaverville College. Swain boarded at the home.

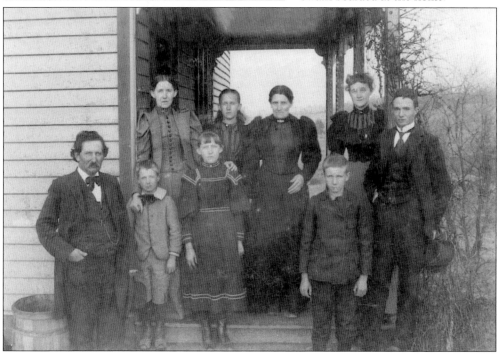

Shown here is William Collis Sprinkle (1854–1930). Sprinkle, along with his son Dr. Charles Nichols Sprinkle Sr., bought the Reagan-Reeves Pharmacy in 1920. Within a few years, they sold it to their pharmacist, Herschel Roberts, and it became the Weaverville Drug Store. (Courtesy of Larry T. Sprinkle.)

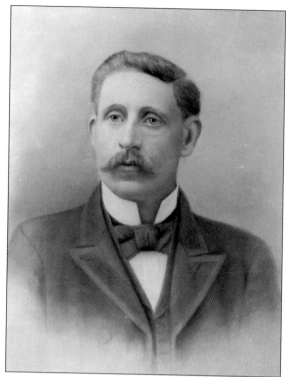

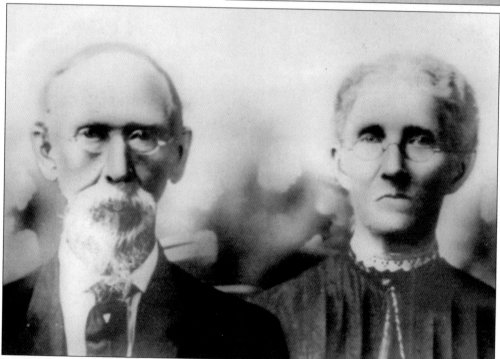

The Penland name has long been prominent in the Weaverville area. Peter Hamilton Penland (1839–1913) and his wife, Helen Eloisa Brittain Penland (1840–1921), are shown here. He was the grandson of George William Penland Sr. (1753–1829).

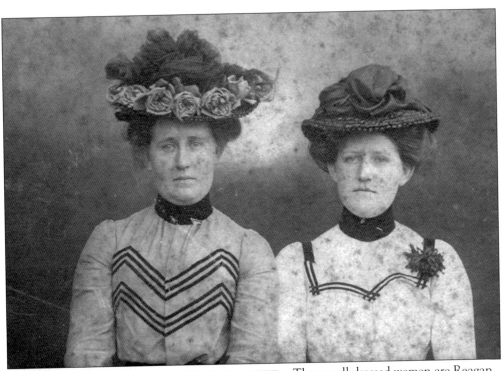

These well-dressed women are Reagan sisters, Mary Jo (1881–1902, above left) and Bonnie Kate (1883–1977, above right). They were the daughters of Dr. William Latta Reagan and Minnie McElroy Reagan.

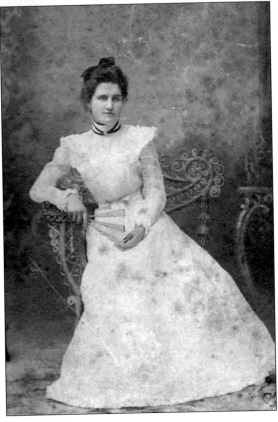

Hannah Eliza Baird Weaver (1846–1928) married Capt. William Elbert Weaver (1842–1935). Their son Zebulon Weaver was born in Weaverville, educated at Weaver College, and had a long and distinguished political career.

Pictured on the left is Laura Leola Gudger (1883–1944), and on the right is her sister Annie Tyler Gudger Dobson (1885–1972). Leola married Charles Edwin Roberts, great-grandson of Jacob Weaver.

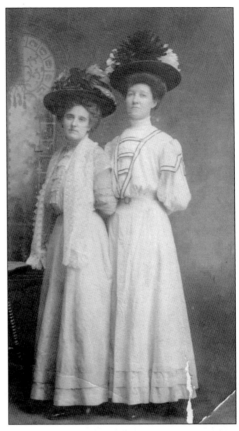

Shown here are Alice Vance Shope Leonard (1882–1957) and her son Cecil Clyde Leonard Jr. Alice was married to Cecil Clyde Leonard Sr. (1877–1940.)

Though born in Asheville, Rose Mary Blackstock (1903–1983), shown here as a child (left) and as an adult (below), came from two important founding families in Weaverville. She was the granddaughter of Thomas Hale Weaver and Tennessee Caecelia Reagan.

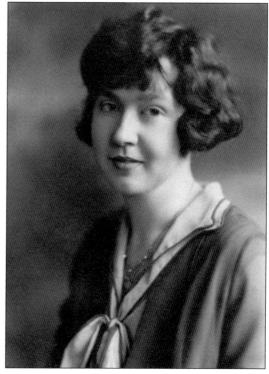

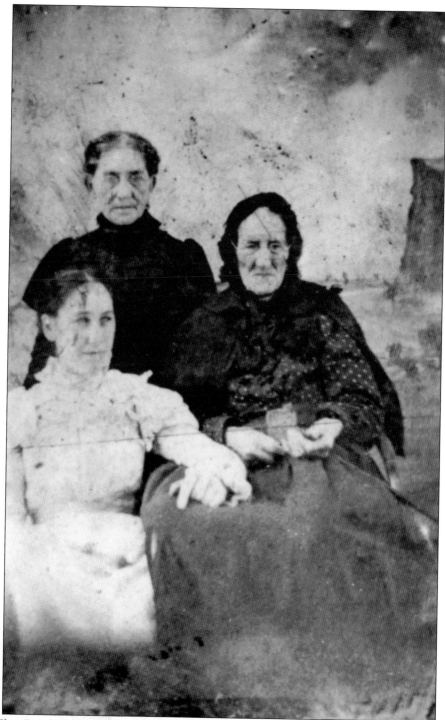

Jane Eliza Baird Weaver (1810–1889) was the wife of Weaverville namesake Michael Montraville Weaver. She is shown here on the right with her daughter Martha E. "Mattie" Weaver Vandiver (standing), wife of John W. "Jehu" Vandiver, and granddaughter Grace Vandiver (left). John Vandiver served as town postmaster from 1886 to 1889.

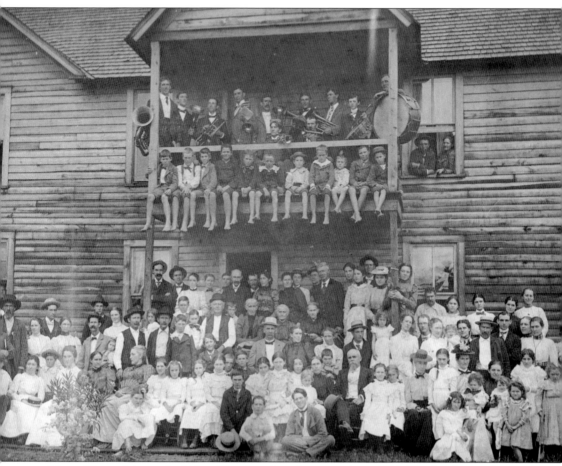

After a 30-year hiatus, the Tribe of Jacob gathered once again in 1896. The family members met, complete with a band, at the old Jacob Weaver homestead, on a hill overlooking Reems Creek.

Zebulon Weaver (1872–1948) was born in Weaverville to William Elbert and Hanna E. Weaver and graduated from Weaver College in 1889. He studied law at the University of North Carolina at Chapel Hill and began a practice in Asheville. He served in the state house of representatives, the state senate, and US House of Representatives before resuming his practice of law in Asheville until his death there. He married Anna Capus Hyman, the daughter of Theodore Hyman, a prominent lumberman in Goldsboro and New Bern, on October 11, 1899. Zebulon and Anna had five children. (Courtesy of the State Archives of North Carolina.)

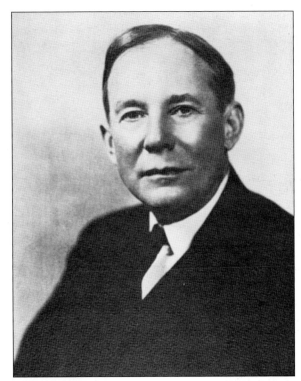

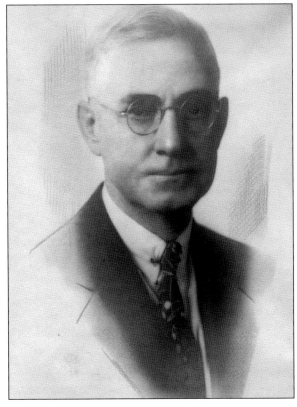

John V. Erskine was a mayor of Weaverville in the early 1900s. He helped oversee much of the town's infrastructure, including an electrical grid, a water system, and a phone system.

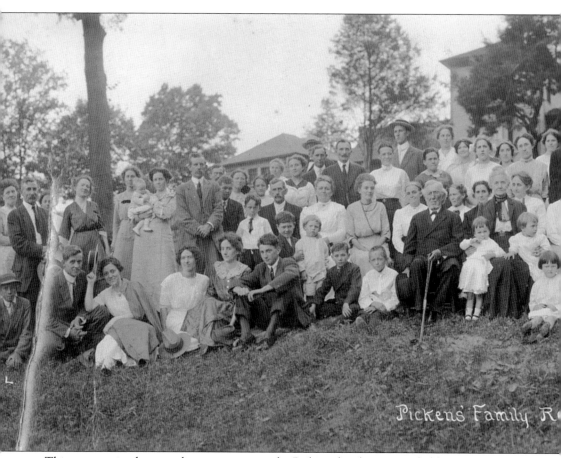

This panoramic photograph commemorates the Pickens family reunion, held on August 8, 1912,

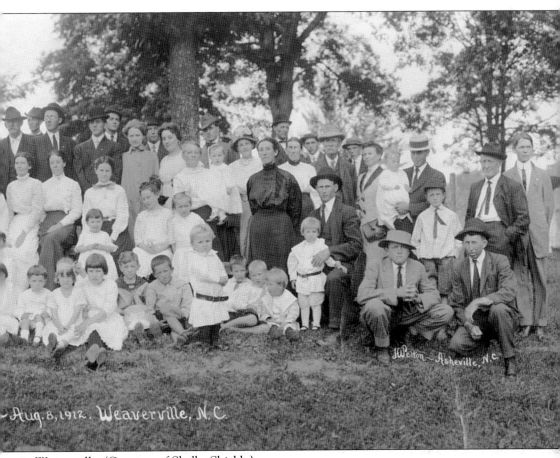

in Weaverville. (Courtesy of Shelby Shields.)

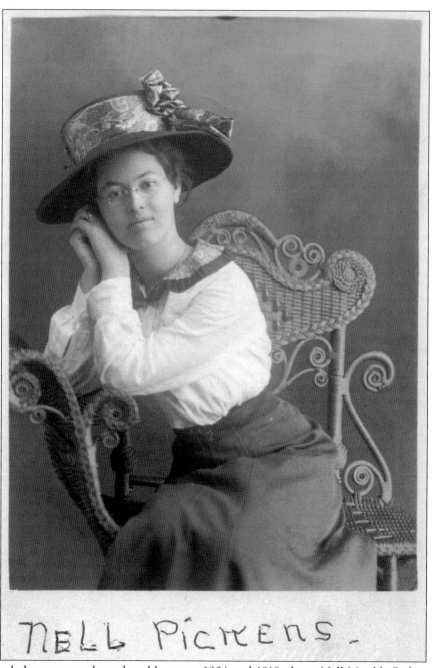

NELL PICKENS.

This real-photo postcard, produced between 1904 and 1918, shows Nell Matilda Pickens. She was born in 1889 to Francis Tarpley Pickens and Clemma Penland. She died in 1962, the same year that she published the book *Dry Ridge: Some of Its History, Some of Its People*. Pickens's book proved to be a great resource in the creation of the present volume. As stated in her book, Pickens was a "librarian, historian, artist, maker of dolls, expert on home-making, collector of rare old treasures of yesteryear, and a person endowed with such an open spirit of friendliness that it reaches out and encircles all who come within the radius of its charm." (Courtesy of Pack Memorial Library.)

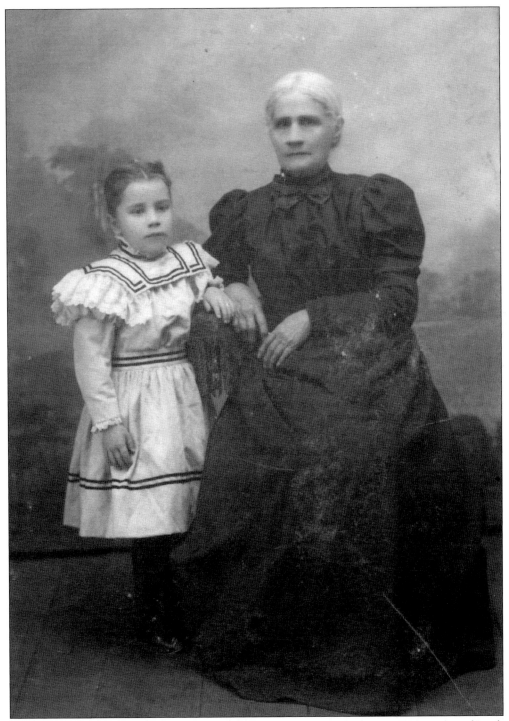

Hester Anne Trotter (right) was born in 1831. She married James Thomas Weaver, son of Jacob Weaver, and the couple had five children. The child posing with her is Mildred Thomas. Hester's son William Trotter Weaver was a well-known businessman in Asheville. W.T. Weaver Boulevard and Weaver Park are named after him.

Alice Josephine Peeke (1878–1967), shown in these two photographs, is the daughter of George Peeke and Mary Weaver. Alice married G. Arch Webster (1878–1935).

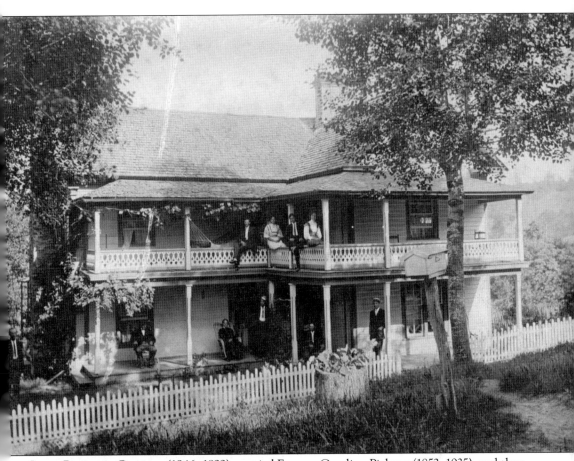

James Benjamin Garrison (1846–1922) married Frances Caroline Pickens (1852–1935), and they had eight children. The family is shown here at their Weaverville home around 1890. Garrison was the grandson of John and Elizabeth Biffle Weaver. (Courtesy of Shelby Shields.)

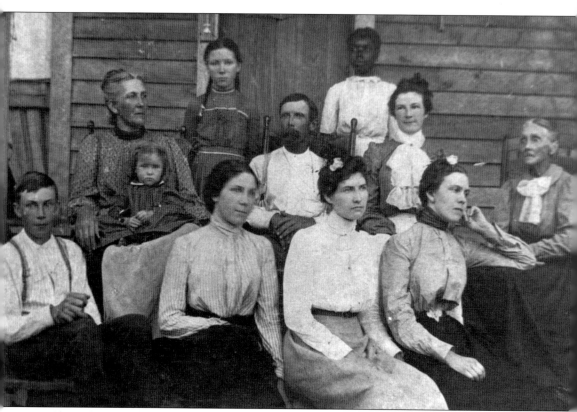

Shown here around 1900 is the family of Robert Henry Weaver (1850–1936), son of Jesse Richardson Weaver (1815–1869) and Julia Ann Coulter (1825–1908). The family members are, from left to right, (first row) Lucius Edward, Glenn Coulter, Lucy M., and Pearl M.; (second row) Agnes Fiske, Robert Henry, Carrie K., and Julia Coulter Weaver (Robert's mother); (third row) Martha Louise "Lou" Webb (Robert's wife), Minnie Estelle, and Hattie Culbreth. Culbreth, who helped raise the family, is buried at the Jacob Weaver Cemetery. Her headstone includes the tribute "A friend loveth, at all times."

Frank Miller Weaver (1858–1942) was the son of John Siler Weaver and Mary Carmack Miller. He served as chairman of the board for Weaverville College and was a food administrator for the chairman of County Councils of Defense, Buncombe County, who urged canning and preserving during World War I. (Courtesy of the State Archives of North Carolina.)

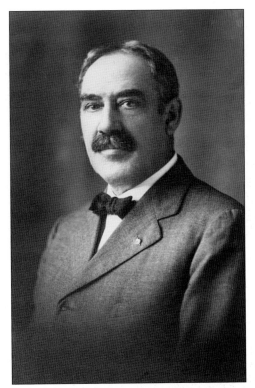

Carroll Pickens Reagan (1896–1980) was the son of Mary Caroline Pickens and James Jerome Reagan. Carroll served in the US Army during World War I. His wife was Anne Shope (1898–1972).

These folks are all dressed up, perhaps for the purpose of sitting for a photograph. They are, from left to right, Doris Weaver, Ernest Donoho, Clyde Weaver, and Clyde Roberts.

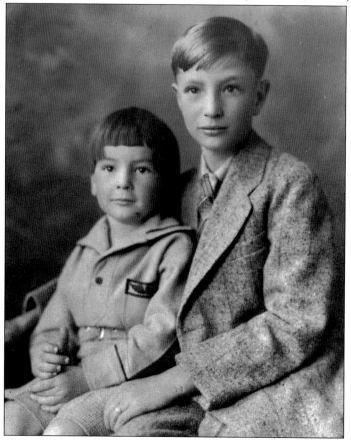

Posing here are Marshall Jerome "Buster" West (left) and Charles Glen West Jr. (1917–1979). Marshall became a town council member. The brothers were co-owners of West Funeral Home. (Courtesy of Gary and Vicki West, West Family Funeral Services.)

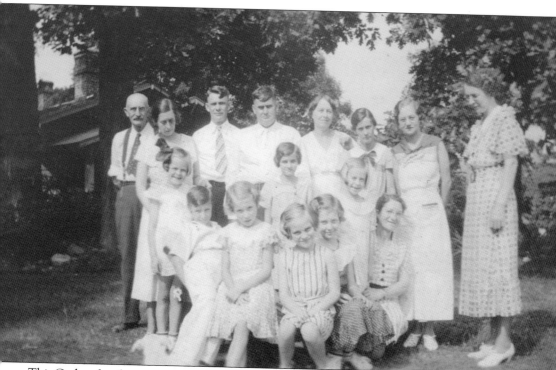

This Gudger family portrait, as well as others from this gathering, were found in the desk of Jacob Weaver. At far left is Robert Samuel Gudger.

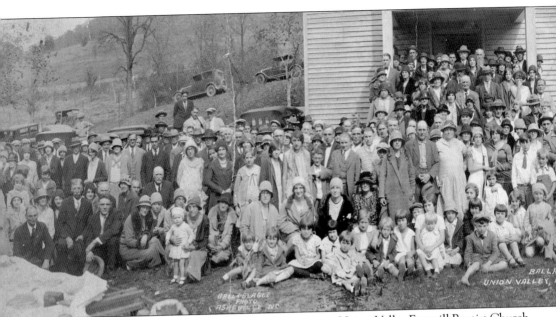

This panoramic photograph of the Ballard family reunion at Union Valley Freewill Baptist Church is dated October 20, 1929, just prior to the stock market crash that started the Great Depression. The Ballards lived on Ox Creek, north of the present Blue Ridge Parkway, a few miles outside

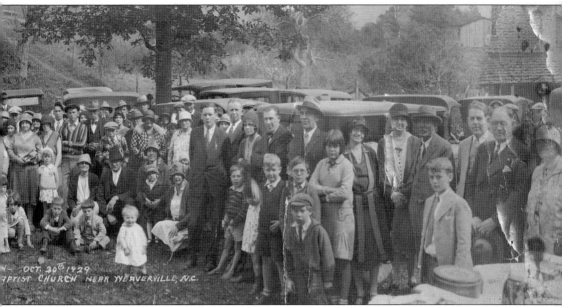

of Weaverville. The little girl standing third from the left (with a pageboy haircut and bangs and next to a woman with a hat on) is Wilma Dykeman, a prominent North Carolina author. (Courtesy of the State Archives of North Carolina.)

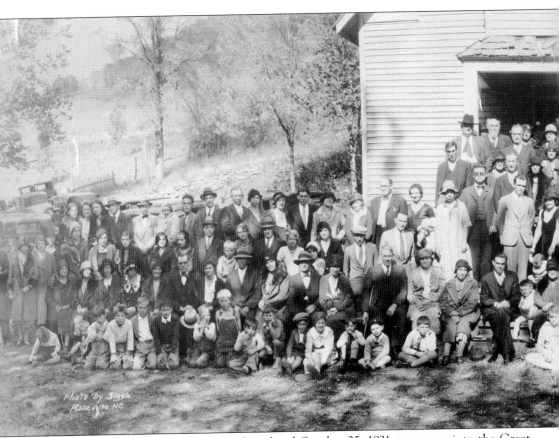

Photo by Slagle
Asheville NC

This Ballard family reunion photograph is dated October 25, 1931, two years into the Great Depression. As with the reunion shown in the previous photograph, this one took place at Union

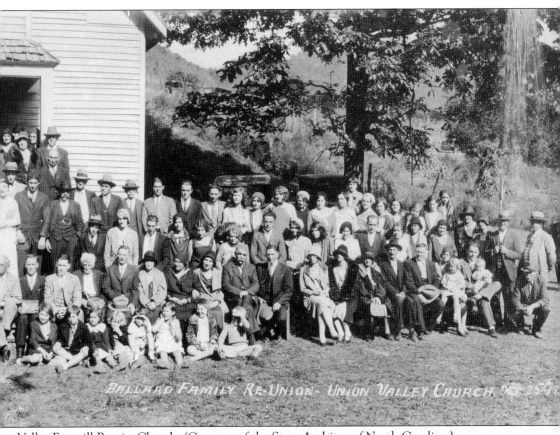

Valley Freewill Baptist Church. (Courtesy of the State Archives of North Carolina.)

Odessa and Howard Grover Coone (1913–1979), shown here in the mid-1930s, were longtime Weaverville residents. (Courtesy of Geraldine Ray.)

In this July 1948 photograph, Howard and Odessa Coone are shown with their daughters Geraldine (Ray) and Frances. (Courtesy of Geraldine Ray.)

Mother and daughter, Odessa and Geraldine Coone (Ray), pose for a photograph around 1947. (Courtesy of Geraldine Ray.)

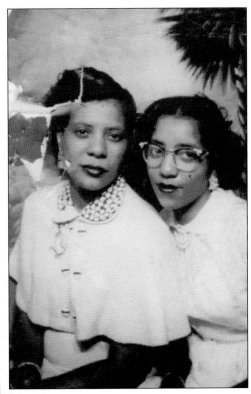

Pictured here in the 1940s are Annie Bell Weston and Joe Carson. (Courtesy of Geraldine Ray.)

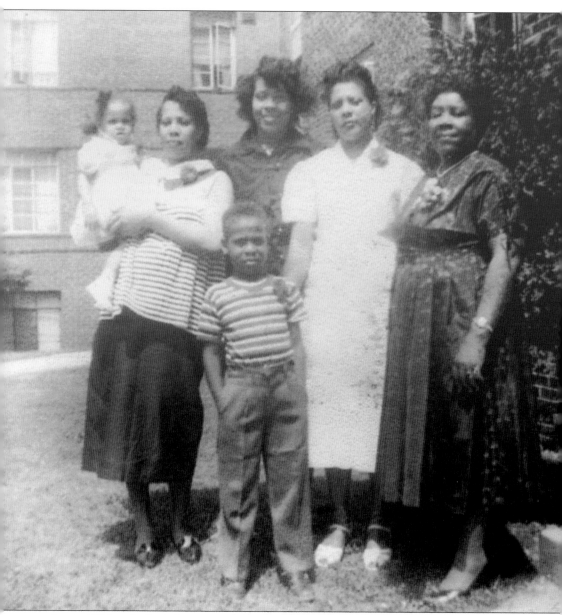

Annie Whiteside (right) poses with her daughters Greta (left), Connie (center), and Odessa (second from right). Also shown are two of Whiteside's grandchildren, who are unidentified. (Courtesy of Geraldine Ray.)

In this photograph, Carrie Cowan (left) and Sarah Weston (right) pose on Hillside Street. (Courtesy of Geraldine Ray.)

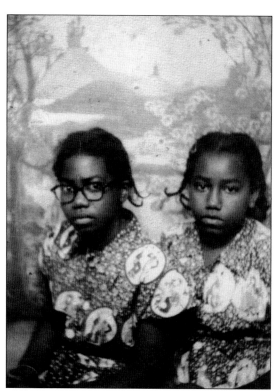

Sisters Ruby (left) and Carrie Ray (right) wear matching dresses for a portrait in the late 1940s. (Courtesy of Geraldine Ray.)

James "Jimmy" Cowan, shown here as a small boy, is a current Weaverville resident. (Courtesy of Geraldine Ray.)

John Arthur (1886–1968) and Alice Palmer Reagan (1886–1967) pose for a photographer. Arthur was the son of William Latta Reagan and Minnie Adelaide McElroy. A graduate of Weaverville College, he helped to operate the Reagan and West Garage. The couple had two sons.

Shown here in August 1962 are Lucy Kate "Bonnie" Reagan (1883–1977), her brother John A. Reagan (1886–1968, at left), and her son William Taylor Reagan (1904–1976, at right). The occasion was John's 50th anniversary with his wife, Alice A. Palmer Reagan.

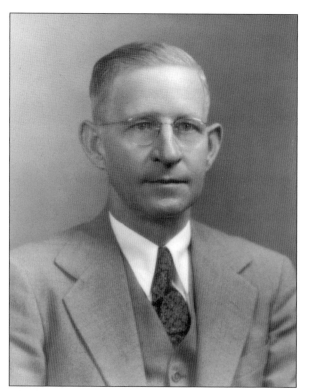

Dr. Charles N. Sprinkle (1888–1964) established a medical practice in 1919. At that time, he and his wife, Bess Gladys Tilson Sprinkle, lived at 170 North Main. In 1922, he moved to 108 North Main Street and located his office in the front rooms of their residence, where it remained until his son Lawrence T. Sprinkle joined the practice in 1948. They then constructed a new medical building at 104 North Main Street. He served on the Weaverville Town Council from 1937 to 1947. (Courtesy of Larry T. Sprinkle.)

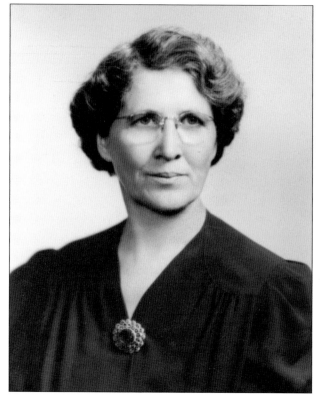

Bess Gladys Tilson (1888–1951) married Dr. Charles Nichols Sprinkle in 1916. She established the library in Weaverville and was instrumental in founding the Weaverville Garden Club. The Bess Tilson Sprinkle Memorial Library is now part of the Buncombe County Library System. She was the daughter of James F. Tilson, president of Mars Hill College. (Courtesy of Larry T. Sprinkle.)

Lawrence Tilson Sprinkle (1920–2004, pictured at right and below) was the second son born to Dr. Charles N. Sprinkle and Bess Tilson Sprinkle. He graduated from Weaverville High School, attended Mars Hill College for two years, and graduated from the University of North Carolina with a bachelor of arts degree. Sprinkle got a medical degree from Jefferson Medical College of Philadelphia and then served two years in the US Army before returning to Weaverville and entering the general practice of medicine with his father in 1948. He was elected to the Weaverville Town Council in 1949 and served 18 consecutive terms. During this period, he served as commissioner/vice mayor (1949–1963) and as mayor (1963–1985). (Courtesy of Larry T. Sprinkle.)

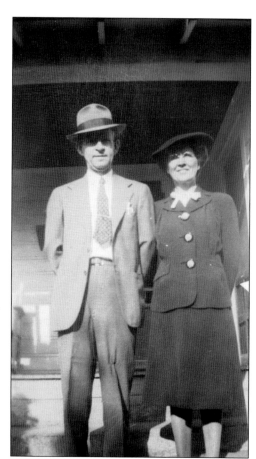

Dr. Charles N. Sprinkle (1888–1964) and his wife, Bess Gladys Tilson Sprinkle (1888–1951), pose for the camera in the summer of 1944. (Courtesy of Larry T. Sprinkle.)

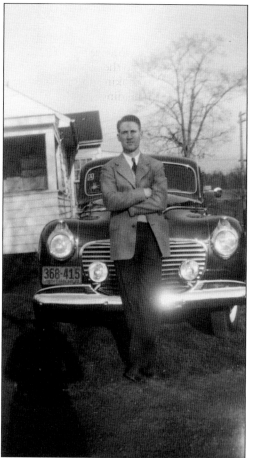

Dr. Lawrence Tilson Sprinkle stands in front of an automobile on April 1, 1943. (Courtesy of Larry T. Sprinkle.)

Two

BUSINESS AND COMMERCE

As soon as settlers begin to move into a region, commerce follows. That was the case in the Weaverville area, too. Going back to the 1800s, businesses in the area included a blacksmith shop, a tannery, a tin shop, a harness-making and saddle shop, a linseed oil mill, and a wheelwright shop.

One of the oldest buildings continuously used for commerce in all of Western North Carolina is on Main Street in Weaverville. Once the home to a general store, it has had many incarnations over the years. It currently houses Blue Mountain Pizza, Keller Williams Realty, and Shop Around the Corner. Buildings in Weaverville have long found new life, as one business fades away and another takes its place. The old firehouse is now Twisted Laurel, Allgood Coffee, and Maggie B's Wine & Specialty Store. Weaverville Drug Company was once the post office, while Well-Bred Bakery was once Weaverville Drug Company. While the Shope family has owned the building that still maintains the family name—Shope's Furniture—it has, over the years, housed a post office, jail, grocery store, and various other businesses. The West Café was in the building now housing Main Street Grill, Clay Spa & Salon, and Art Accents Framing & Gallery. Banks that were once on Main Street now house an Asian restaurant (Soba) and a bookstore/café (Norbury). The building that houses Curtis Wright Outfitters was once the Arthur Robinson Store. Fortunately, the Town of Weaverville has saved many of its Main Street buildings, though, of course, some have been lost to time.

Weaverville is home to a number of manufacturing businesses as well. AB Emblem makes patches for the US military, NASA, and a number of police and fire departments across the country. Arvato Digital Solutions is the largest manufacturer of CDs and DVDs in the world. Balcrank produces an array of fluid-dispensing systems, such as pumps, control handles, and oil-tank packages. Karpen Steel makes doors and frames. OTC creates prosthetic limbs. The Sample Group NC produces samples of such items as window treatments and flooring. Thermo Fisher Scientific is a world leader in scientific equipment.

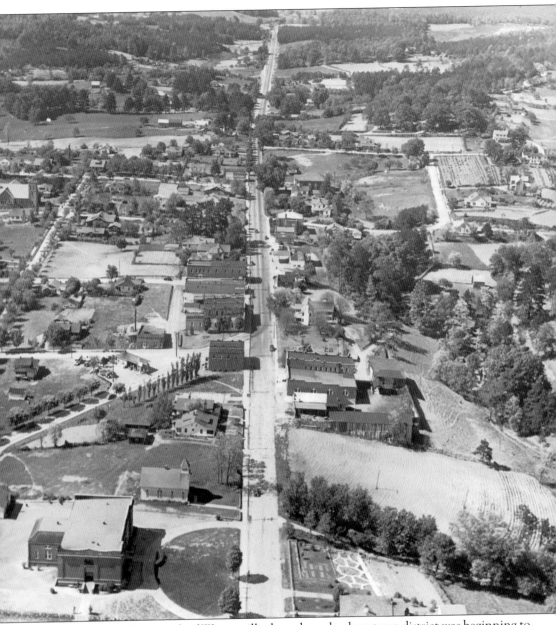

This 1940s aerial photograph of Weaverville shows how the downtown district was beginning to grow. (Courtesy of Gary and Vicki West, West Family Funeral Services.)

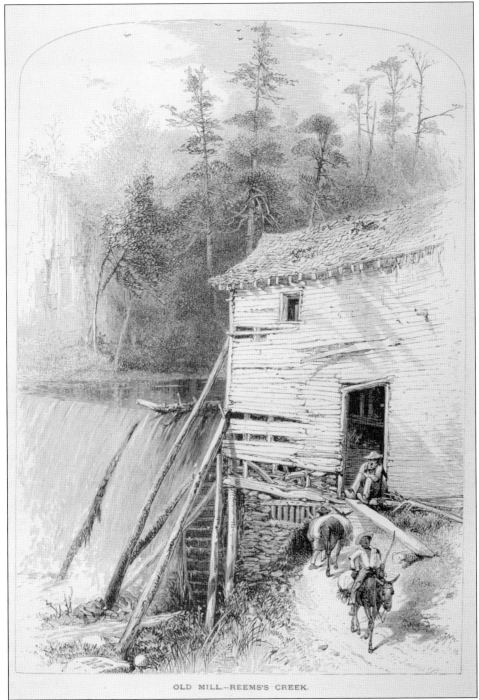

OLD MILL.—REEMS'S CREEK.

Mills were common up and down Reems Creek. This 1855 print shows one of the Reems Creek mills at work. A miller sits in the doorway of the mill building, awaiting a customer who is bringing mule-laden products to be ground into meal. Another patron is leaving the mill with his meal draped across his mule. To the left of the mill is a waterfall that turns the waterwheel. (Courtesy of the State Archives of North Carolina.)

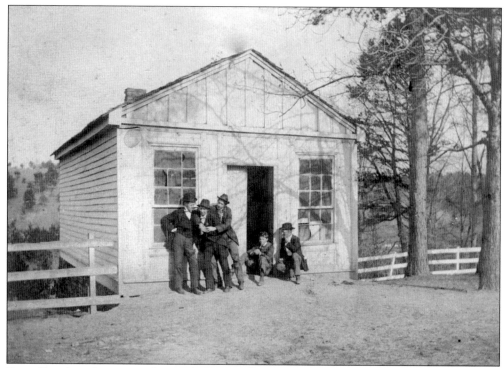

Post offices have been in and around Weaverville since the mid-1800s. This was a local US Post Office sometime between 1896 and 1900, when William E. Weaver was the postmaster.

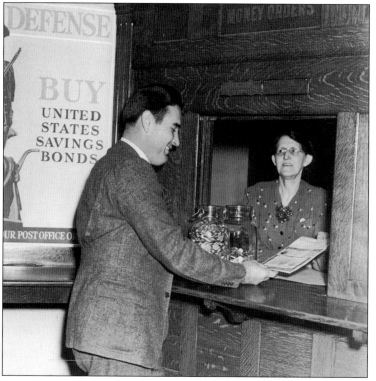

One of Weaverville's old post offices was located in the back of the Shope building. Here, Ed West receives mail from longtime resident Bonnie Kate Reagan, who was postmaster from 1914 to 1922 and from 1936 to 1953. (Courtesy of Gary and Vicki West, West Family Funeral Services.)

Dr. William Latta Reagan, a second-generation physician, operated out of this medical office. His father was Dr. James Americus Reagan.

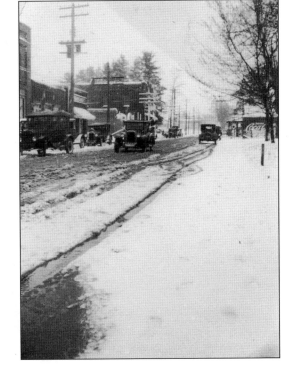

A new age of prosperity came to Weaverville in the early 1900s, due to a number of factors: automobiles, electricity, a water system, and a trolley that traveled back and forth to Asheville several times a day. Main Street is shown here around 1917, just after a snowfall.

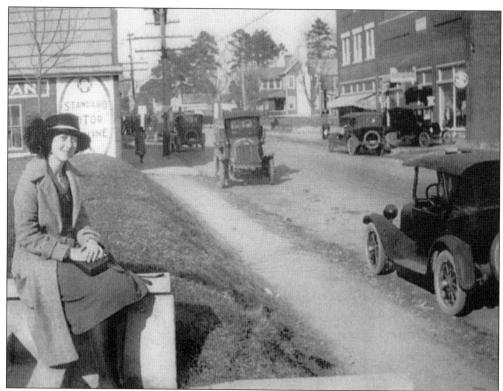

In the 1920s, a woman sits on the steps of a house that today is the site of the Weaverville Primary School. It is across from the current Weaverville Town Hall.

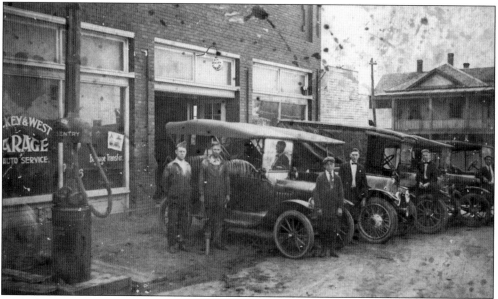

With the advent of the automobile came the need for service stations and maintenance facilities. The Main Street garage and service station shown here would later become the town's fire station. Behind the building was a livery stable. The house at right was the old West Hotel. (Courtesy of Gary and Vicki West, West Family Funeral Services.)

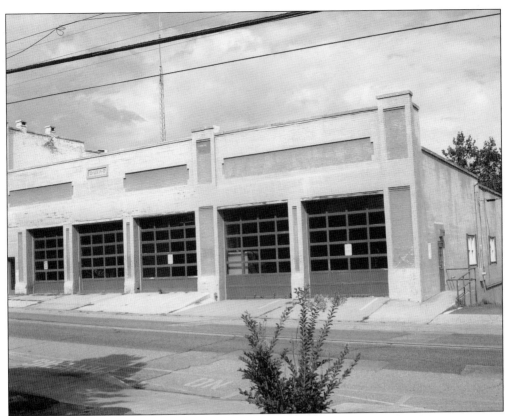

The old fire station on Main Street sat empty for six years before it was purchased by Lou Accornero. He says that he sat across the street, looking at the building for hours, before a voice finally spoke to him, telling him to give it a second chance. The building today houses the restaurant Twisted Laurel, along with Allgood Coffee and Maggie B's Wine and Specialty Store. The basement is being renovated for office space. (Courtesy of Lou Accornero.)

Before West Funeral Services built its current facility on the corner of Alabama and Merrimon Avenues, this structure on that spot served as the town's funeral home. The business has been operated by three generations of Wests. Today, it is owned by Gary and Vicki West. (Courtesy of Gary and Vicki West, West Family Funeral Services.)

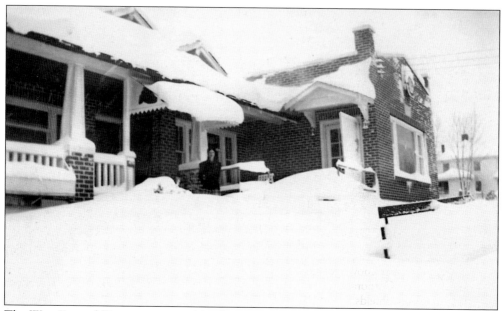

The West Funeral Home is seen on March 16, 1937, just after a late-winter snow. (Courtesy of Gary and Vicki West, West Family Funeral Services.)

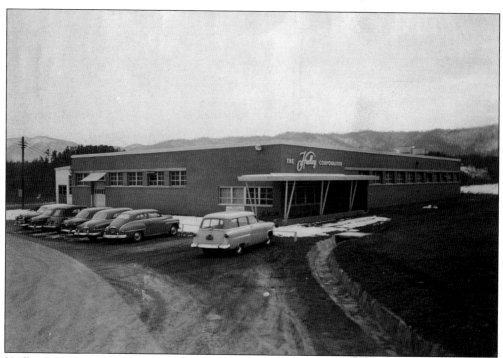

Hadley Corporation on Reems Creek Road brought a new age of manufacturing to the Weaverville area. (Courtesy of Pack Memorial Library.)

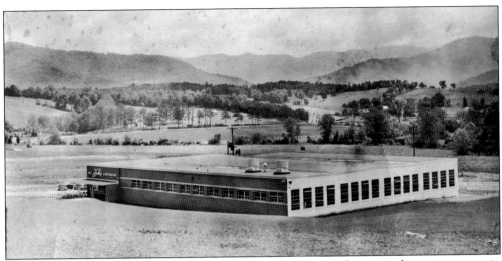

A textile manufacturer known for some of the best camel hair, cashmere, and vicuña sweaters in the country, Hadley Corporation was in the building that now houses the Balcrank Corporation. (Courtesy of Shelby Shields.)

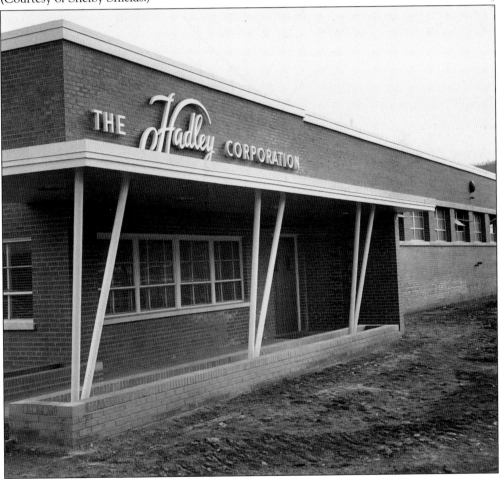

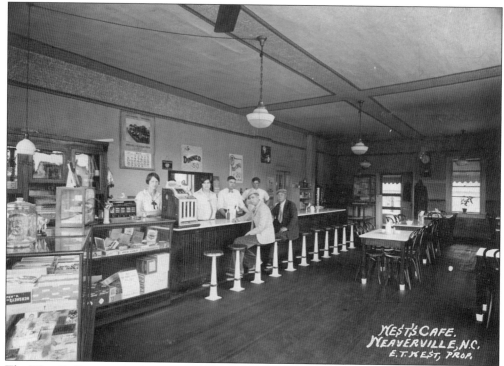

The West Café was a popular eating establishment in Weaverville. It was located in the building that now houses Main Street Grill, Clay Spa & Salon, and Art Accents Framing & Gallery. (Courtesy of Gary and Vicki West, West Family Funeral Services.)

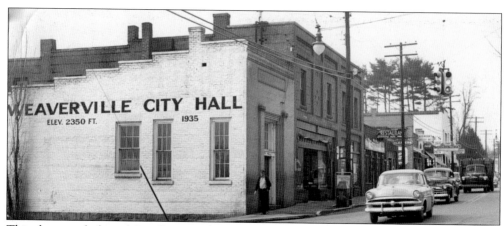

This photograph shows Main Street in the mid-1950s. Weaverville Town Hall has since moved to its current building at 30 South Main Street. The building shown here at 12 North Main Street now houses Aabani Salon.

The Shope building has evolved over the years and over three generations of Shope owners. Operated today as Shope's Furniture by Scott Shope, it was once a grocery store. It was even used as a town hall in its early days. The old jail cell is still in the basement. (Courtesy of Scott Shope.)

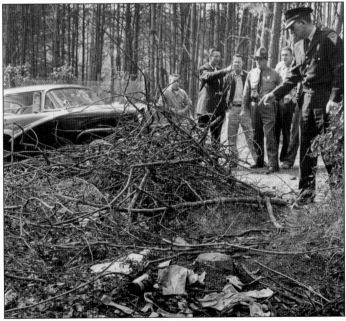

The Bank of French Broad, formerly across Main Street from the Weaverville Library, was the target of two robberies in the course of a year between 1969 and 1970. In one of those cases, the money was recovered at the old Weaverville City Dump, as shown here. (Courtesy of Gary and Vicki West, West Family Funeral Services.)

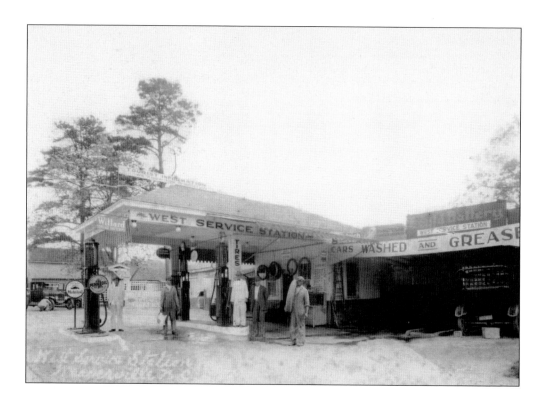

In the days of full-service gas stations, the West Service Station had a full crew of men waiting to assist customers. The above photograph, which serves as the cover of this book, features a 1927 Model T Ford (left) and a Model T Touring Car from 1925 or 1926 (right). The men are, from left to right, Troy West, Bass Miller, John Reagan, Jim Rogers, and "Slim" Coleman. Below is the West Service Station looking across Main Street, which was tree-lined at that time.

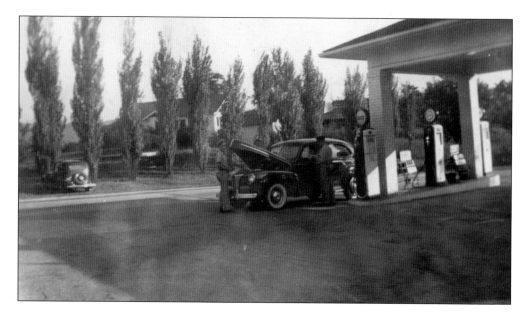

The West family had several business interests in Weaverville. The gentleman shown here in front of West Café is Ed West, son of Euhl and Ella West. (Courtesy of Gary and Vicki West, West Family Funeral Services.)

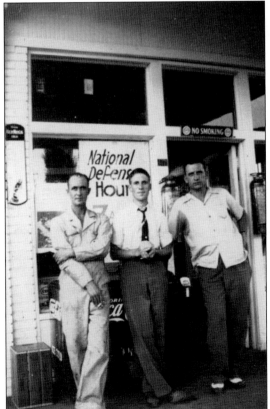

The West Service Station for years stood as a centerpiece of the town. The station is shown here in the 1940s. The gentleman in the center is L.T. Sprinkle, who later served as mayor. (Courtesy of Larry T. Sprinkle.)

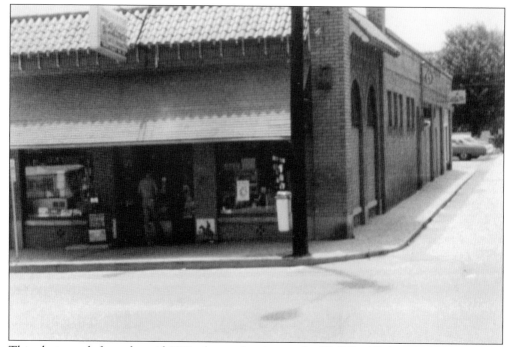

This photograph from the mid-1970s shows what is now the Well-Bred Bakery building, when it was purchased by its current owner, Lou Accornero. Note that some of the windows on the side were bricked up. A later renovation brought the windows back to their original design. (Courtesy of Lou Accornero.)

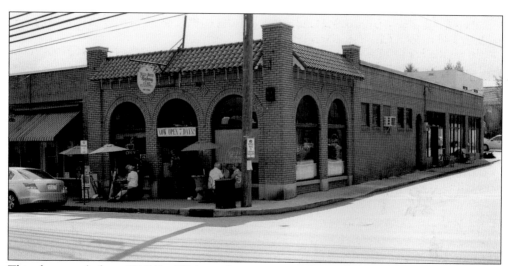

This photograph shows Well-Bred Bakery after renovation. It stands on the corner of Main Street and Florida Avenue. (Courtesy of Lou Accornero.)

Three

HOMES AND INNS

The first home in the village that became Weaverville belonged to the namesake of the town, Rev. Michael Montraville Weaver. It was located on Main Street where the municipal parking lot is today. Other homes soon followed and quickly populated this quaint new town. That said, homes had been in the area long before Weaverville was incorporated. At Reems Creek is the Vance Birthplace Historic Site, where Zebulon Baird Vance's father, David, created a homestead sometime between 1785 and 1790. Not too far away is the Brigman-Chambers House, which had its initial log portion constructed in 1845. As early settlers of Reems Creek, the Brigman and Chambers families were farmers and land speculators. The 1845 cabin was built by John Brigman and later sold to John Chambers's son Joseph.

Right on the border of what is now Weaverville and Woodfin stood the home of Zebulon H. Baird, a relative of Zebulon Baird Vance. The house, built in 1878, has been moved and still exists unoccupied; its condition sadly deteriorates daily. In Flat Creek, the Joseph Eller house on Clarks Chapel Road was built in 1880. The John G. & Nannie H. Barrett Farm was placed in the National Register of Historic Places in 2013. It now operates as Ox-ford Farm Bed & Breakfast Inn and is located at 75 Ox Creek Road, well down Reems Creek.

The original portion of the Dry Ridge Inn Bed and Breakfast at 26 Brown Street was built in 1849 as a parsonage for the old Salem Campground. It was used during the Civil War as a camp hospital for Confederate soldiers. In 1888, it was purchased by C.C. Brown, who moved into the house with his wife and eight children. The Browns occupied the home until 1958.

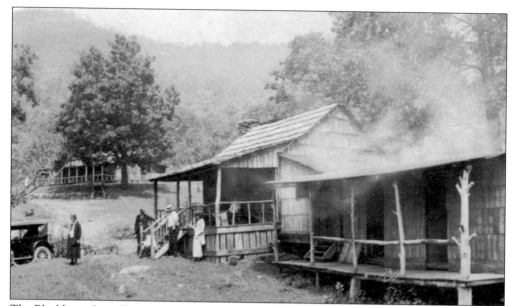

The Blackberry Inn offered accommodations at the end of Reems Creek. This photograph shows the Campfire Girls Camp, but the lodge was popular among those with money who would come up from the Lowcountry during the summer.

The Bethel Home on Hamburg Mountain was established by Rev. Homer Casto, a well-known Methodist minister and poet, as a sanitarium for tubercular patients. He ran the home from 1919 to 1940 with help from some local Methodist women. After that, the property was used as a private dwelling, and it later became a boardinghouse before falling into disrepair.

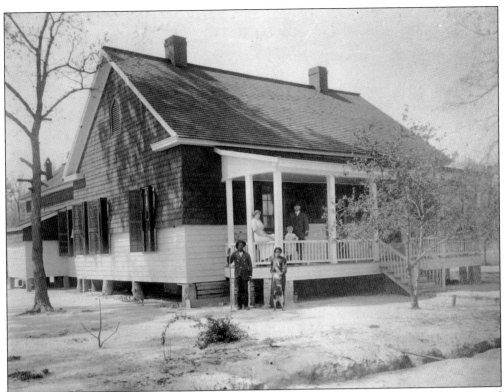

The home of Henry Ritter Mortimer, great-grandson of Michael Montraville Weaver, is pictured here. (Courtesy of the State Archives of North Carolina.)

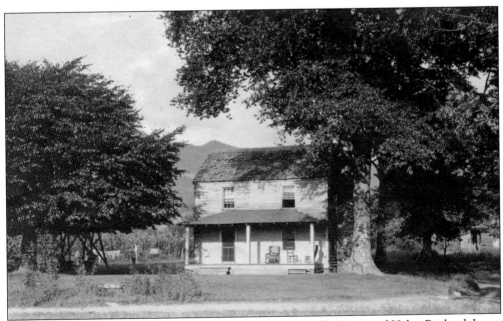

The Penland Home, shown here in the 1950s, was established by Peter and Helen Penland. It was later the home of Robert and Ada Penland. (Courtesy of the Hensley family.)

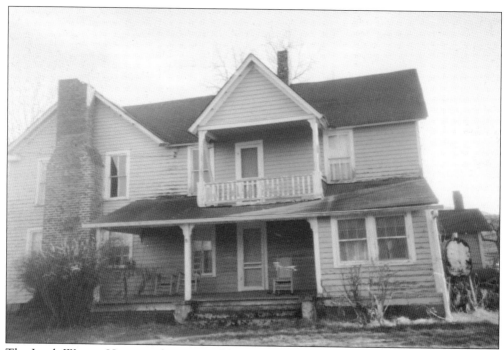

The Jacob Weaver Homestead is pictured here in 1998. Over the years, it was home to many reunions of the Tribe of Jacob. Jacob Weaver was the eldest son of John Weaver, one of the area's initial settlers.

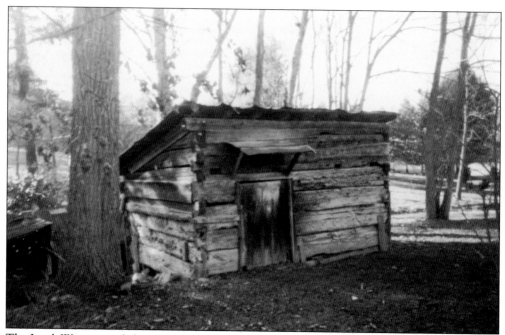

The Jacob Weaver smokehouse included logs from the original 1811 house. The property still sits on a hilltop overlooking Reems Creek and has a small family cemetery on the grounds.

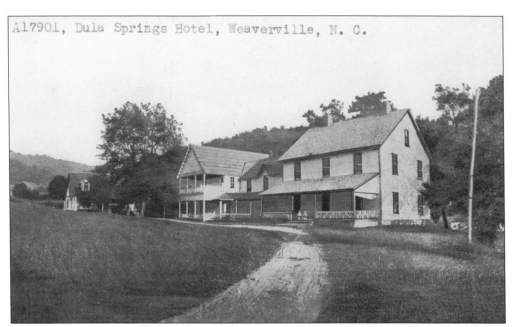

Dula Springs Hotel was a popular summer resort for more than 40 years on the land and springs initially owned by Thomas Martin Dula (1832–1901) and his wife, Elizabeth J. Baker Dula (1848–1910). Charles Chambers, a cousin to Tom Dula's eldest daughter from his first marriage, bought part of the Dula farm and got the hotel running. It had tennis courts, a bowling alley, a miniature golf course, and a dance floor. It was sold to Arthur Guthrie in the 1940s, but better roads, cars, and roadside hotels had changed the nature of summer travel, and the hotel closed a few years thereafter.

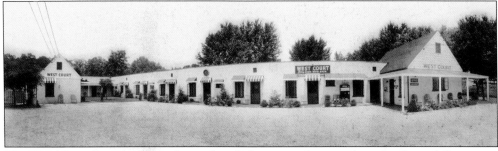

The West Motor Court was part of a new breed of accommodations taking the place of classic inns, such as Dula Springs Hotel and the Blackberry Inn. It operated from 1946 to 1967 and was eventually demolished in 1989. (Courtesy of Gary and Vicki West, West Family Funeral Services.)

65

The Euhl and Ella West house was torn down to make way for the Clyde Savings Bank. The old former building now houses a restaurant called Soba. (Courtesy of Gary and Vicki West, West Family Funeral Services.)

The Euhl and Ella West house at 76 North Main Street was torn down to make way for the Clyde Savings Bank. The old building now houses a restaurant called Soba. (Courtesy of Gary and Vicki West, West Family Funeral Services.)

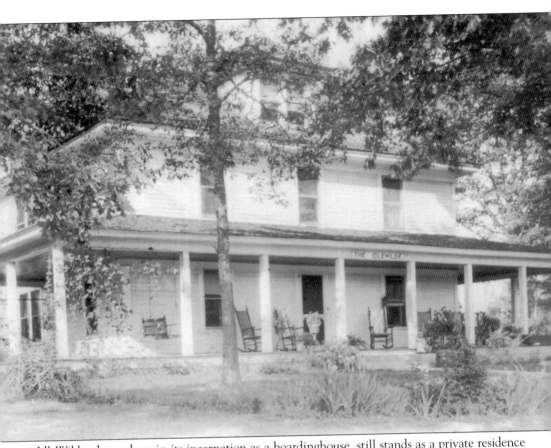

IdleWilde, shown here in its incarnation as a boardinghouse, still stands as a private residence on Alexander Road.

Four

CHURCHES
AND CEMETERIES

Reems Creek Township includes nearly 50 cemeteries. Many contain just a handful of graves. Some have been lost, such as Biffle Cemetery, which dated to the late 1700s and vanished with the creation of Lake Juanita.

Located on Main Street just past Weaverville Elementary School is the Old Weaverville Cemetery, originally known as the Rims Creek Methodist Church Cemetery. This old cemetery is the final resting place of many influential founders of Weaverville, including numerous members of the Weaver family, such as John Weaver and his wife, Elizabeth, along with their youngest son, Michael Montraville Weaver. Other familiar surnames that can be found in the Old Weaverville Cemetery are Baird, Garrison, Pickens, Reagan, and Roberts. A log church building once stood near the center of the cemetery. This church eventually evolved to be the Weaverville United Methodist Church, located first on Church Street. Today, it stands on Main Street.

Before moving on to the largest cemetery in the area, mention should be made of the two Clark's Chapel Cemeteries. One is the church cemetery located behind Clark's Chapel Church. The other is in front of and across the road from the church. The cemetery is now owned by West Funeral Services. Together, these two cemeteries make up one of the largest burial sites in the area, just north of Weaverville's town limits.

The largest cemetery in the area is West Memorial Park, on a hillside above town on Roberts Street. It was established in 1893 and managed by Frank Roberts. It was previously known as Roberts Cemetery. By the 1920s, West Funeral Home took over the management and maintenance of the cemetery as a public facility. Currently, the cemetery comprises 10 developed acres and 6 3/4 undeveloped acres.

Many churches in the area have roots going back before the 1900s. Reems Creek-Beech Presbyterian dates to 1791, when Rims Creek Church was organized in a log building on old Reems Creek Road near Parker Cove Road. John Weaver was one of the founders, but he soon switched over to Methodism. Among the largest churches in the area are Weaverville First Presbyterian and First Baptist Church Weaverville. These were not founded until the 1900s. First Baptist was originally in the building that now serves as the Bess Tilson Sprinkle Memorial Library. The church moved just across Pine Street into its present building.

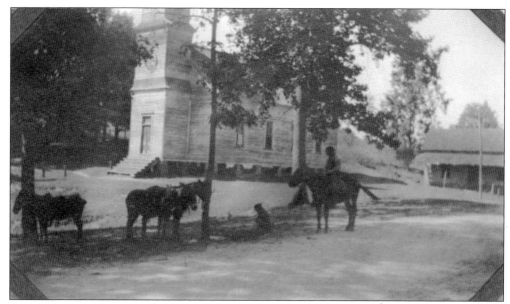

This photograph, taken sometime between 1908 and 1917, shows what was called The Center, located in the Georgetown subsection of Flat Creek between Weaverville and Stocksville. Because it was described as a center, the church may have been used for a school operated by the Presbyterian Board of Home Missions. (Courtesy of Pack Memorial Library.)

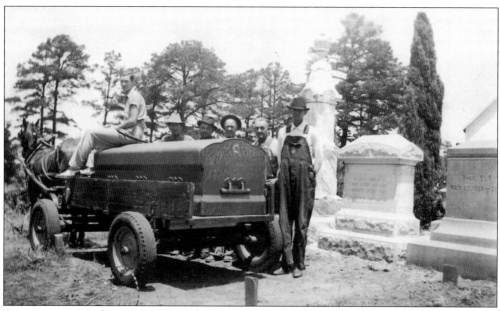

Causing some confusion is the fact that there are two Clark's Chapel Cemeteries. One is the church cemetery, located behind Clark's Chapel Church. The other, in front of and across the road from the church, is now owned by West Funeral Services. In this photograph, Charles Glen West Jr. drives the horse and buggy that is carrying a steel vault for burial. He is the father of the current owner of West Funeral Services, Gary West. (Courtesy of Gary and Vicki West, West Family Funeral Services.)

West Memorial Park traces its roots to the end of the 19th century. Shown here are the entrance to the park (above) and grave diggers (below). (Courtesy of Gary and Vicki West, West Family Funeral Services.)

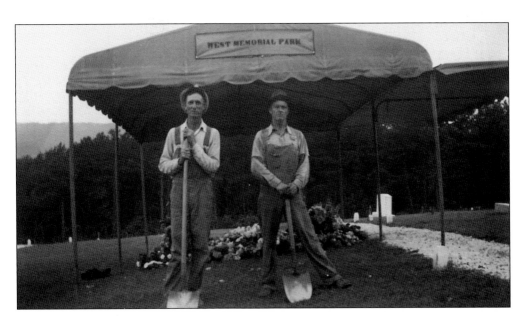

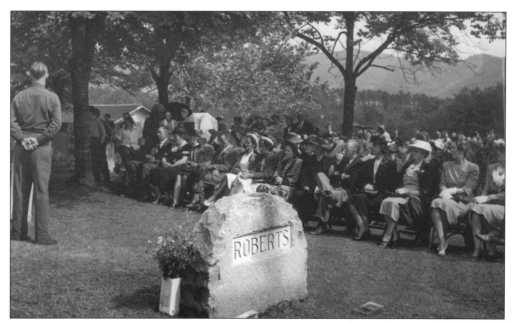

Many Weaverville soldiers fell during World War II. These photographs show a military funeral at West Memorial Park. (Courtesy of Gary and Vicki West, West Family Funeral Services.)

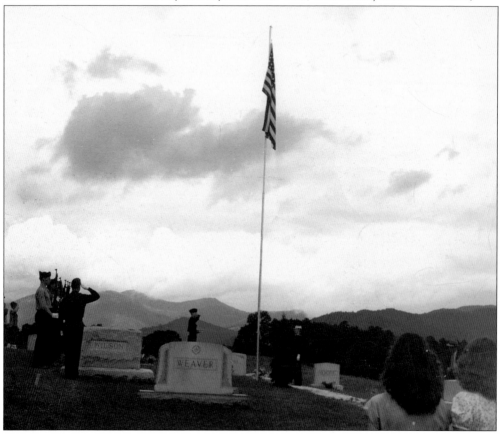

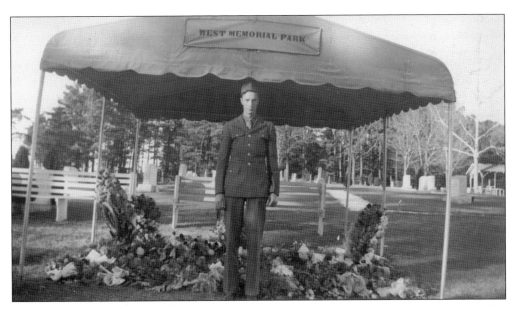

Above, a serviceman stands in front of a gravesite. Below, mourners gather for a service. (Courtesy of Gary and Vicki West, West Family Funeral Services.)

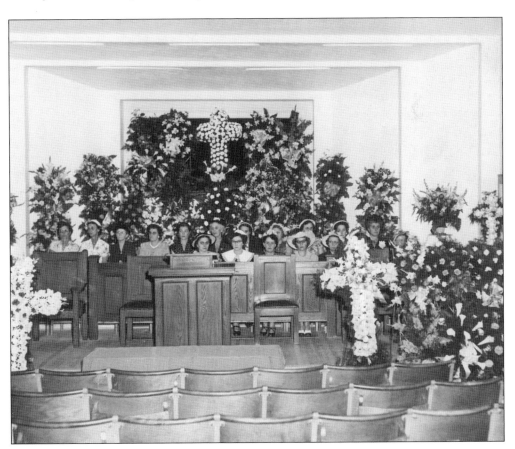

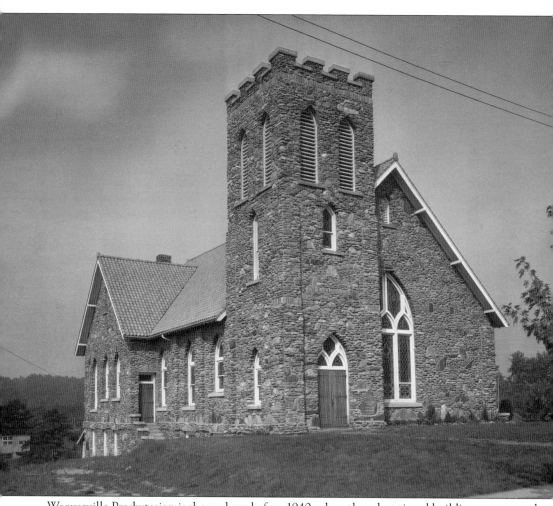

Weaverville Presbyterian is shown here before 1940, when the educational building was erected. (Photograph by Ewart M. Ball; courtesy of UNC Asheville.)

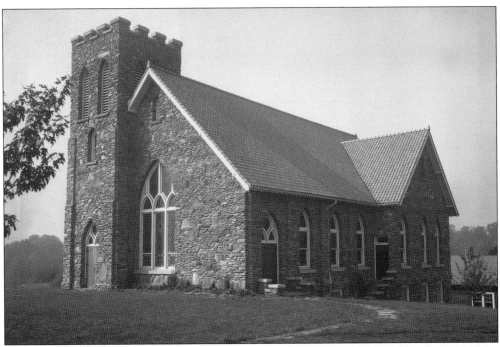

These photographs show the exterior and interior of Weaverville Presbyterian Church on Alabama Avenue. (Photograph by Ewart M. Ball; courtesy of UNC Asheville.)

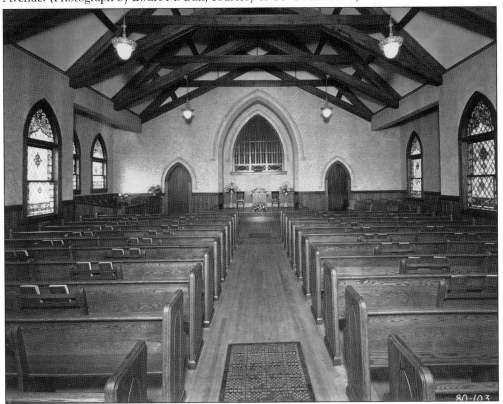

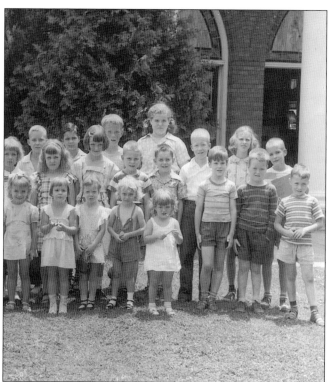

Vacation Bible School (VBS) was a popular summer activity for local children. Here, VBS attendees gather for a group photograph in the 1950s. (Courtesy of Gary and Vicki West, West Family Funeral Services.)

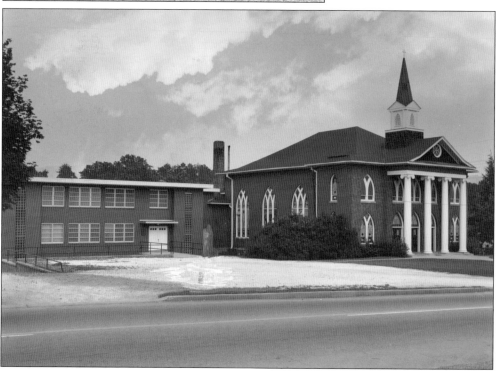

Weaverville United Methodist, shown here in 1985 at 85 North Main Street, has roots that extend to the very early 1800s. (Courtesy of Weaverville United Methodist Church.)

It is said that, around 1892, Frances Goodrich rode down Dula Springs Road on horseback and saw the need for a school in the area. She came back to live with her sister, and they established a school and missionary center under the auspices of the Presbyterian Church (USA). That eventually evolved into Brittains Cove Presbyterian Church, and some of the members are shown here. It was one of the few churches in the area that had classrooms on the ground floor and the sanctuary upstairs.

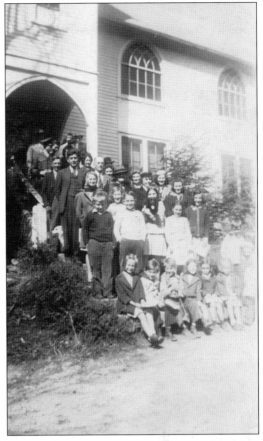

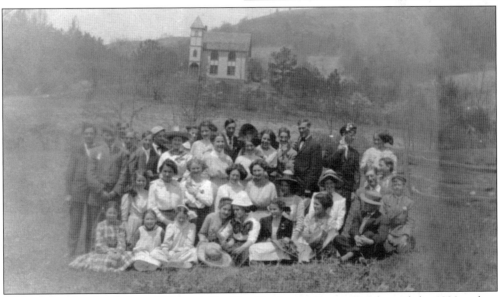

Several church schools dotted Weaverville, Flat Creek, and Reems Creek until the 1920s, when schools began to consolidate. This is believed to be one of the Baptist schools and its students in the area.

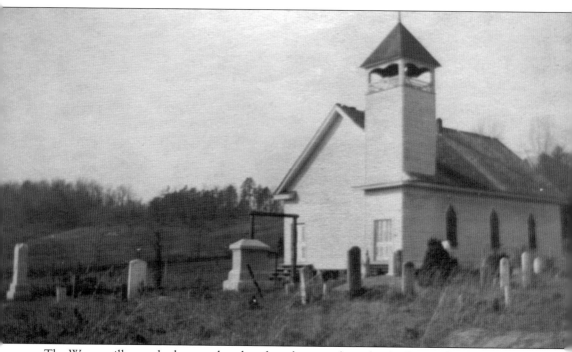

The Weaverville area had many churches that also served as schools. One such school is shown in this photograph from the Dry Ridge Historical Museum.

Five

SCHOOLS AND COLLEGES

Education has long played an important role in Weaverville and the surrounding communities. Interestingly, Weaverville College existed before the town of Weaverville was incorporated. The college was founded in 1873, and the town was chartered in 1875. The school's first president was Dr. James Americus Reagan. Weaverville College was developed on grounds that housed an academy started by the Sons of Temperance in 1851. Even before that, in the same area, a school was located at the site of the old church camp meetings, which were evangelical events with English and Scottish origins. Land for the college was given by Rev. Michael Montraville Weaver. Through gifts and acquisitions, the campus eventually grew to 55 acres. Weaverville College became Weaver College in 1912 and changed its status from a four-year institution to a junior college. It merged with Rutherford College to become Brevard College in Brevard, North Carolina, in 1934.

Like most communities, schools popped up wherever a need occurred, including in Weaverville, Reems Creek, and Flat Creek. A few early schools in the area include Alexander Chapel, Beech Academy, Bethel School, Beech Elementary, Brittain's Cove, Carson Elementary, Chestnut Grove, Dillingham, Flat Creek, Hemphill, Locust Grove, Morgan Hill, and the long gone but not forgotten Miss Fannie Hoofnagle's Private School. Weaverville High (initially called Reems Creek Valley Township High School) stood from 1928 to 1954 where Weaverville Elementary is today. It welcomed the high school kids from Beech and Hemphill, in addition to those from Weaverville proper.

Weaverville Elementary was built in 1920 on the site of what is now Weaverville Primary. North Buncombe High School, located in Flat Creek on the grounds of the old Asheville-Weaverville Race Track, opened on August 26, 1954, a result of the consolidation of Barnardsville, Flat Creek, French Broad, Red Oak, and Weaverville.

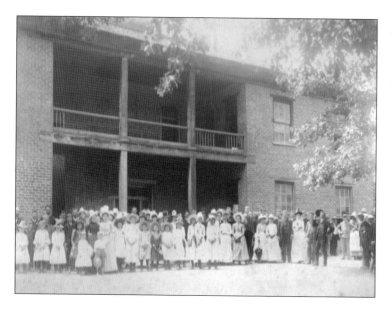

Always an exciting milestone, this scene marks the 1887 commencement at Weaverville College.

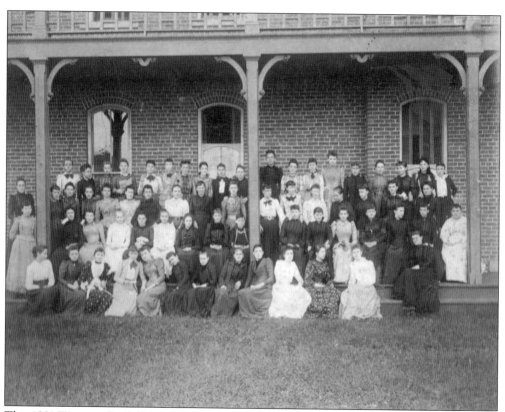

This 1891 Weaverville College photograph includes Sedalia Myrtle Roberts Hyder (1875–1966), who was the daughter of Franklin Pierce Roberts and Mary Elizabeth Weaver. She was married to Dr. Robert Lee Hyder (1879–1937), and the couple had two children.

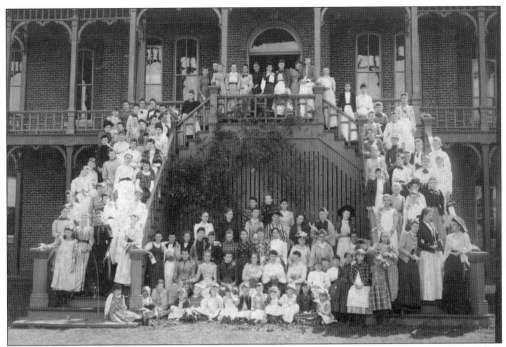

This group photograph, dated September 28, 1893, includes Edna Reagan (1876–1945), who married James Claude Cauble (1877–1966). She is the daughter of Daniel H. Reagan, a Civil War veteran, and Eliza Jane Weaver. Also pictured is Myrtle Roberts Hyder, age 18.

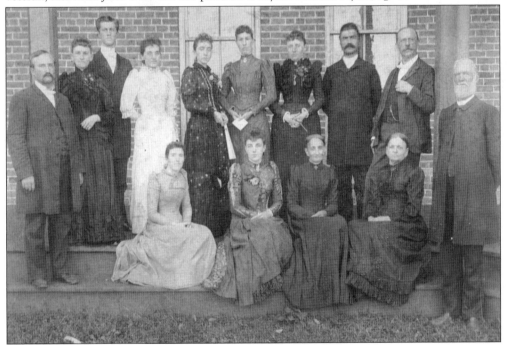

This photograph possibly shows faculty from Weaverville College. Writing on the back of the photograph only names Myrtle Roberts Hyder (1875–1941), who was married to Robert Lee Hyder (1879–1937). Myrtle was the daughter of Franklin Pierce Roberts and Elizabeth Sue Weaver.

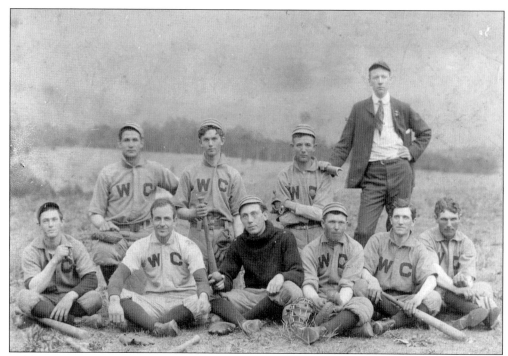

Athletics have always played a part in college life in America. The Weaverville College baseball team poses in 1900. Shown here are, from left to right, Mark Weaver, Elsas Lotspiech, Lucius Weaver, Morris Roberts, Liston Weaver, Charlie Roberts, Clyde Weaver, Claude Byerly, Fred Garrison, and Bob Reynolds.

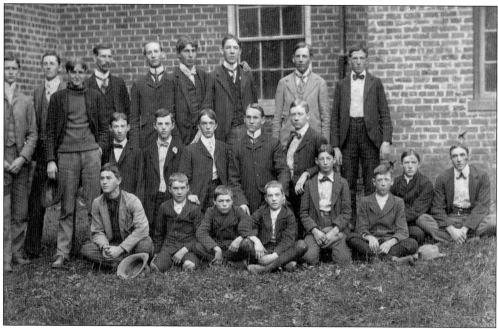

This photograph depicts the Weaverville College Delphian Society in October 1901.

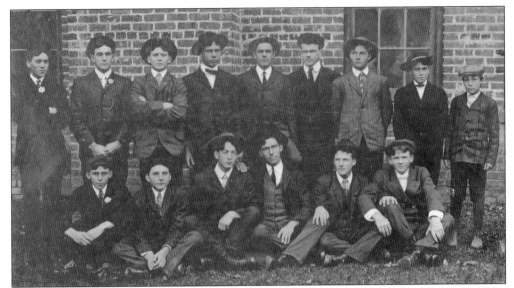

The Weaverville College Delphian Society, shown here in 1905, was a literary club for male students.

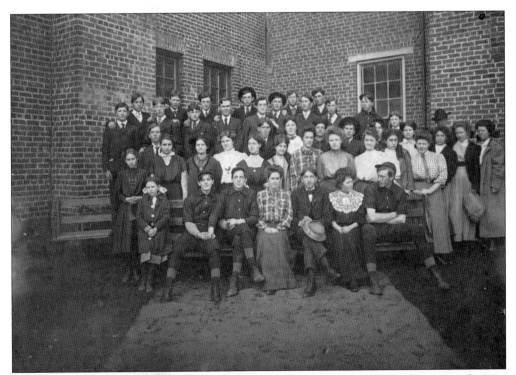

The Weaverville College Mnemosynean Society was a literary organization for women. It was a sister organization to the all-male Delphian Society. This photograph was taken around 1907.

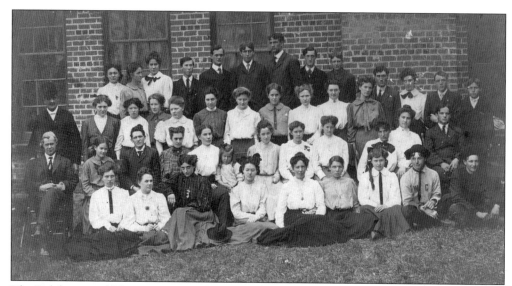

The Delphians and Mnemosyneans of Weaverville College pose here in 1907. The college's 1916 catalog had this to say about its literary societies. "We have four literary societies: The Cliosophic and the Delphian are for young men; the Euterpean and the Mnemosynean are for young women. Much of the work in reading, declamation, and debate will be done in the societies. Friendly contests between the societies and with similar societies in other schools will be arranged. Work in the societies is compulsory, for such training is essential to success. Each student will be required to unite with one of these societies within three weeks after his arrival at the college."

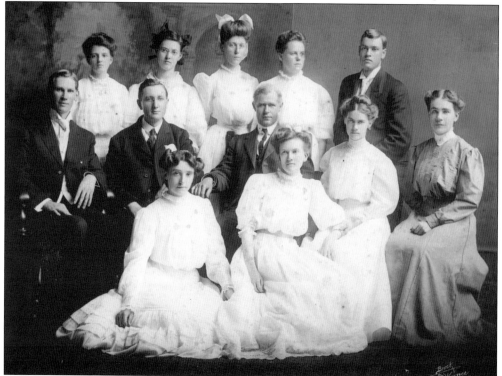

The Weaverville College class of 1907 gathers for a photograph.

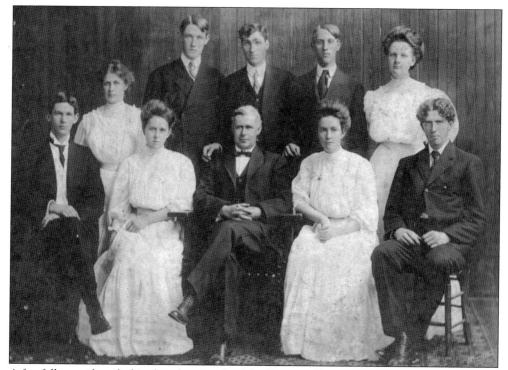

A few folks are identified in this photograph of the Weaverville College class of 1908. A Professor Abernathy is at center in the first row. The back of the photograph names Horace Sawyer and Grady Reagan, but their positions are not indicated.

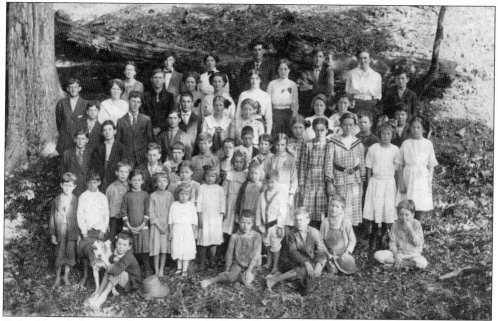

Before the advent of public school systems and consolidation, numerous schools dotted the areas of Flat Creek, Weaverville, and Reems Creek. One of those small schools was Chestnut Grove. This photograph is believed to show its students in 1912 or 1913.

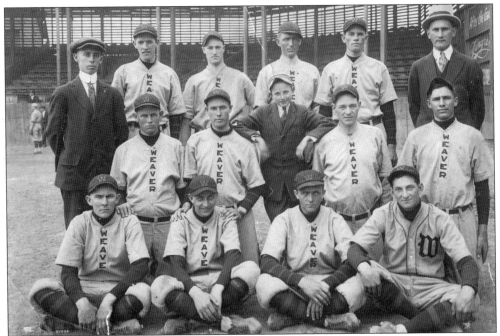

This photograph of the Weaver College baseball team in 1914 includes the batboy, Ty West (second row, center). The school shortened its name to Weaver College in 1912.

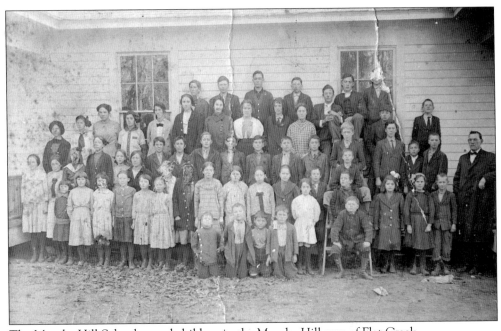

The Murphy Hill School served children in the Murphy Hill area of Flat Creek.

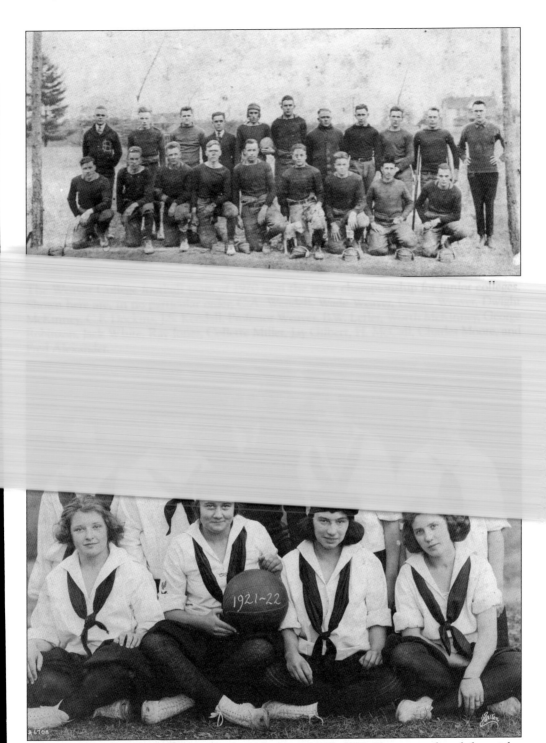

This is the Weaver College women's basketball team of 1921–1922. Shown are, from left to right, (first row) Elsie Burleson (later Teague), Madge Hancock, Mary Ellen Kinsland, and Lucille Caldwell; (second row) Margaret Pickens, Daphne Hunter, Coach Weaver, Margie Hipps, and Grace Moore.

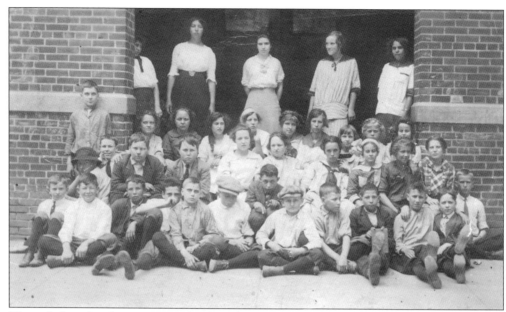

This is believed to be a mission school in the Weaverville or Dula Springs community in the early 1900s.

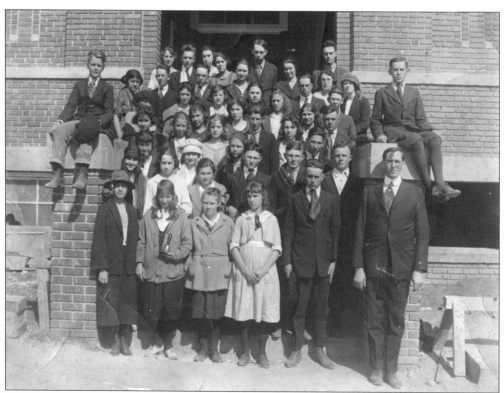

Posing here around 1922 are members of some of Weaverville's upper grades. J.W. Bennett (first row, right) is the principal.

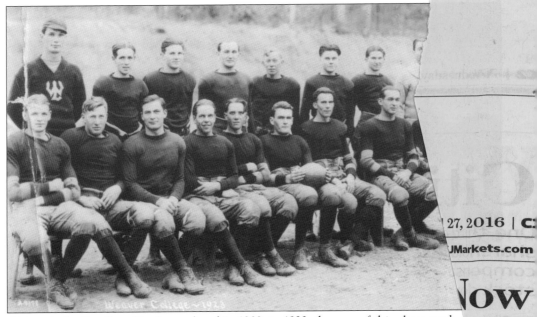

Although the first Rose Bowl was played in 1902, in 1923, the year of this photograph, was still a relatively new sport. In this photograph of the Weaver College team, William T. is identified, standing third from left in the second row.

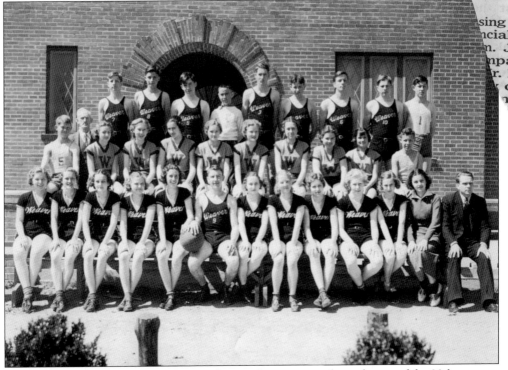

Basketball was one of the few athletic endeavors for women in the early part of the 20th century. Here, the Weaverville High School boys' and girls' basketball teams pose in 1937. It appears that even the cheerleaders made it into this shot, in the second row. (Courtesy of Larry T. Sprinkle.)

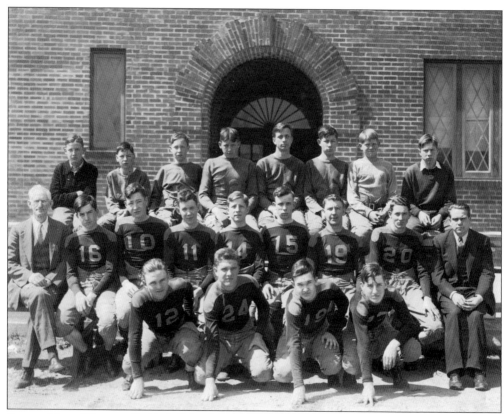

Some of these Weaverville High School football players may have been dreaming of playing for the University of North Carolina, Duke, or North Carolina State. All three of those schools had outstanding records in the Southern Conference in 1937, when this photograph was taken. (Courtesy of Larry T. Sprinkle.)

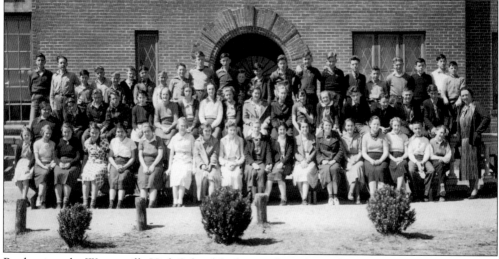

By the time the Weaverville High School freshman class of 1937 (pictured) came along, the new school building was nearly a decade old. It had opened in 1928 on South Main Street, where Weaverville Elementary stands today. (Courtesy of Larry T. Sprinkle.)

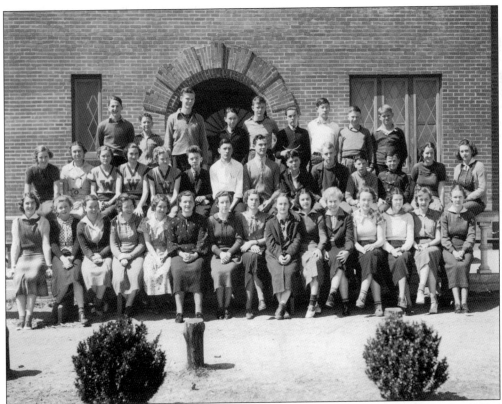

One can imagine the voices coming from these members of the Weaverville High School Glee Club. They are gathered in 1937, when Benny Goodman, Count Basie, Duke Ellington, and Bing Crosby were topping the *Billboard* charts. (Courtesy of Larry T. Sprinkle.)

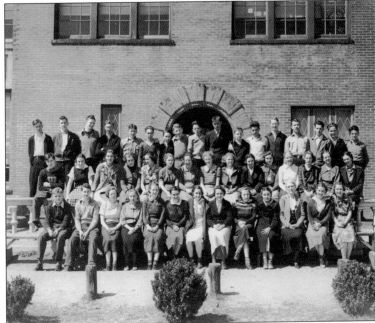

Pictured here is the Weaverville High School junior class of 1937. (Courtesy of Larry T. Sprinkle.)

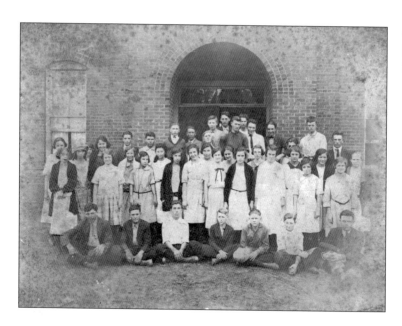

This is an early look at Weaverville College students.

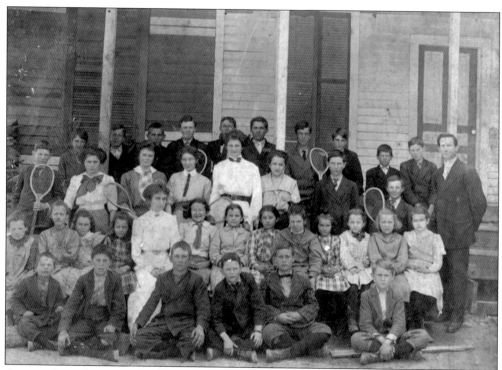

Are members of a tennis club shown here? Or did these guys just really love their tennis rackets? The answer is lost to time, but this is another scene from Weaverville College, which also taught students not yet of college age.

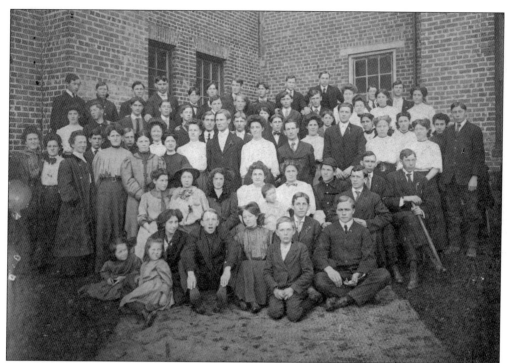

This is another group photograph from Weaverville College.

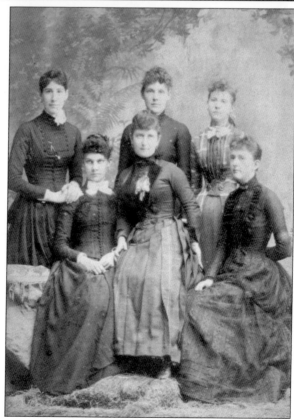

The young women posing in this undated photograph from Weaverville College may be students. It is also possible that they are faculty members.

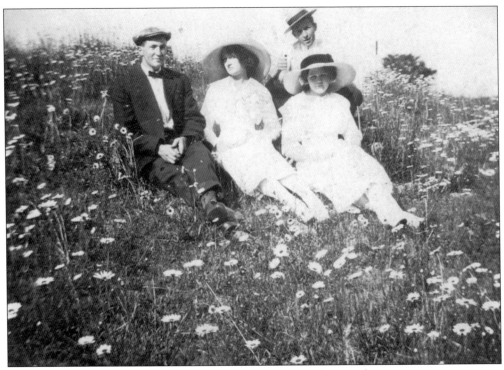

These Weaver College students enjoy some time away from their studies.

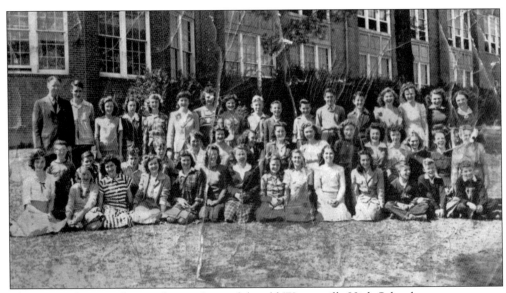

This group photograph was taken in front of the old Weaverville High School.

Six

TRAVEL AND LEISURE

This chapter takes a look at how residents got around over the years and what they did in their spare time. Of course, spare time has sometimes been in short supply. The town grew up as a residence for the common man. Today, it is thought of as a bedroom community of Asheville, or a place for retirees who have moved from elsewhere. But the town's roots as a blue-collar village remain strong. Even so, people have always had a desire to take time off for leisure activities and to travel.

Obviously, there were no planes, trains, or automobiles in the early days of Dry Ridge, which would later become Weaverville. In the early 1800s, a trip from Flat Creek to Reems Creek in a horse and buggy might take a full hour or more. A trip from Weaverville to Charlotte would take about a week. As new transportation technology was introduced to the region, people suddenly were able to get from point A to point B much more quickly.

In the book *Dry Ridge: Its History, Its People*, it is written that C.W. Pickens was the first automobile owner in the village. He is said to have owned a red Maxwell. Cars caught on quickly. Soon, trips from Weaverville to Flat Creek, Reems Creek, or even Asheville were accomplished in much less time. The Grove Park Inn, which opened in Asheville in 1913, was visited by the likes of Henry Ford and Harvey Firestone. Perhaps those gentlemen tested their products on Weaverville streets.

A trolley connected Weaverville with Asheville for about a dozen years early in the 20th century, making travel and leisure a reality to Weaverville residents. In Asheville, residents could connect to other local trolley lines or even catch a passenger train to faraway places, at greater speeds than had previously been imagined. Just a few years earlier, horses had been the main mode of transportation. Weaverville had a bus line, too, for a number of years. In general, technology was making travel and adventure much easier than it had ever been.

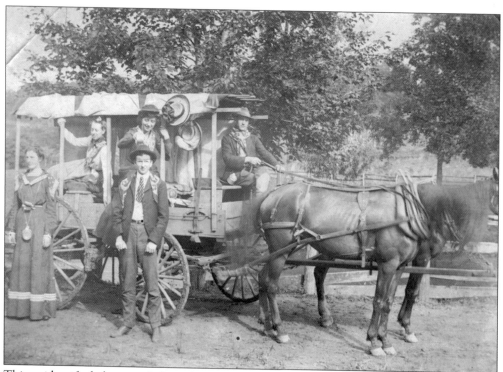

This unidentified photograph from the Dry Ridge Historical Museum seems to depict some sort of traveling entertainment show.

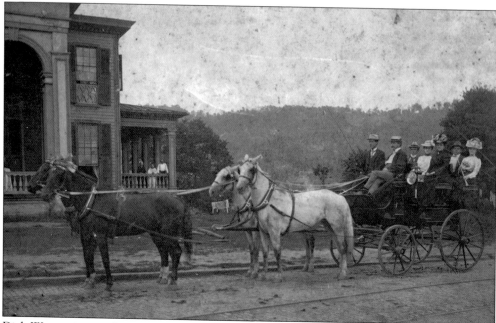

Dick Weaver is seated, second from the left, in the buggy. He is shown with other Weaverville citizens in 1902. This is a few years before the birth of his son Richard M. Weaver Jr., who was considered a leader in conservatism and a defender of Southern traditionalism in the years after World War II.

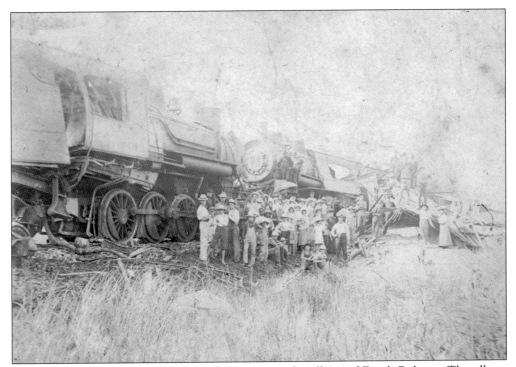

This photograph of a train derailment came from the album of Frank Roberts. The album eventually found its way to the Dry Ridge Historical Museum.

Travelers between Asheville and Weaverville in the 1910s may have come across this unusual road sign. This photograph was taken in the early days of paved roads. (Courtesy of the State Archives of North Carolina.)

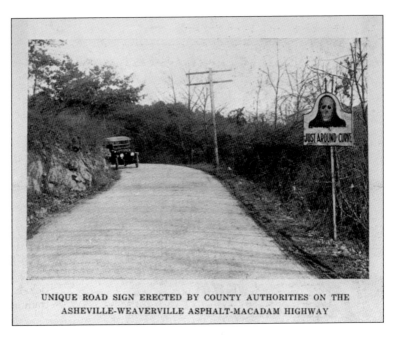

UNIQUE ROAD SIGN ERECTED BY COUNTY AUTHORITIES ON THE
ASHEVILLE-WEAVERVILLE ASPHALT-MACADAM HIGHWAY

Camping attire and equipment has certainly changed over the past century. These Weaverville residents are on the way to or returning from a camping trip. A few names, some incomplete or difficult to read, are listed on the back of the photograph, including Roy (or Ray) Reagan, Mona Devenish, Alice Devenish Hall, Grace C., Grady Reagan, Virge, and D.J. Weaver.

A group picnic was a wonderful leisure activity on a summer day. These Weaverville residents are enjoying their watermelon while posing for the camera.

The outdoors has long provided recreational opportunities for area residents—and still does today. Going for a hike or scrambling around on some rocks provided an inexpensive date.

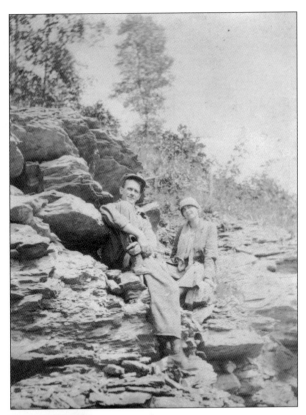

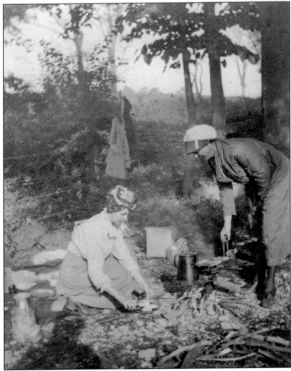

With so much natural beauty all around, camping was a quick, easy, and inexpensive form of leisure in the area.

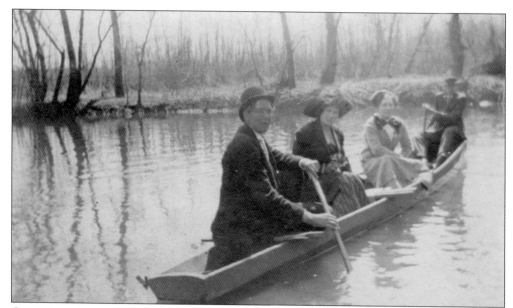

Canoeing attire—and the canoes themselves—have come a long way since this photograph was taken. Among other things, these folks are not wearing flotation devices. This image was found among the personal effects of Jacob Weaver after his death.

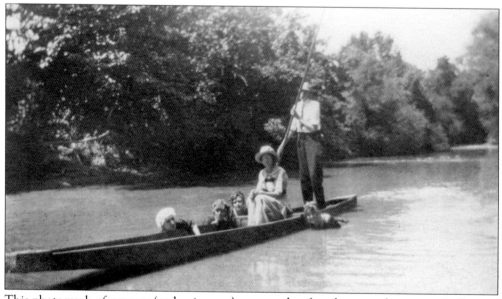

This photograph of canoers (and swimmers) was another found among the personal effects of Jacob Weaver.

It appears that two young mothers decided to cool down with their kids in the local creek.

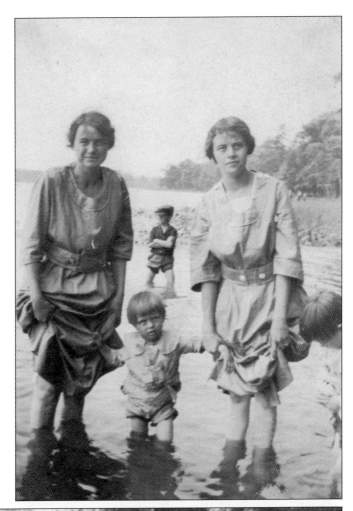

These women are enjoying some time in one of the local waterways.

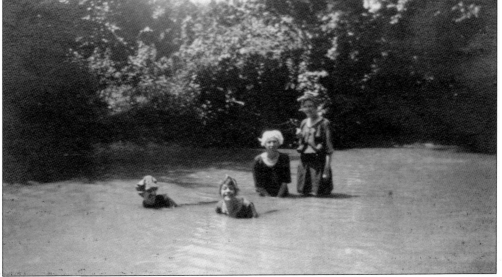

The back of this photograph identifies the women at the creek as Agnes ?, Thelma Gudger, and Tip ?. Thelma Woods Adams (1898–1970) was married to Troy Colen Gudger and lived in Weaverville, where she is buried.

This Weaverville postcard shows an unidentified celebration.

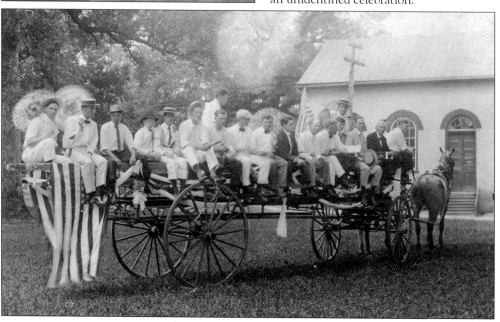

This couple on a ship are apparently connected to Weaverville resident Alice Peeke, daughter of George and Mollie Kate Weaver Peeke. The back of the photograph reads, "For Alice Peeke." They are on board the *Northland*, a ship built in 1911 for the Norfolk & Washington Steamboat Company. The ship transported freight and passengers from Washington, DC, to Norfolk, Virginia.

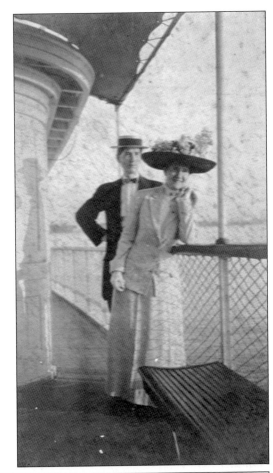

This Weaverville resident, identified on the back of the photograph as a Mr. Lewis, proudly drives his car in 1912.

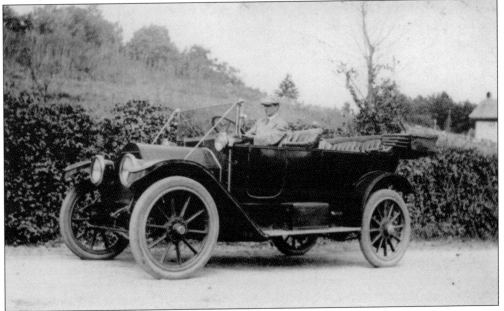

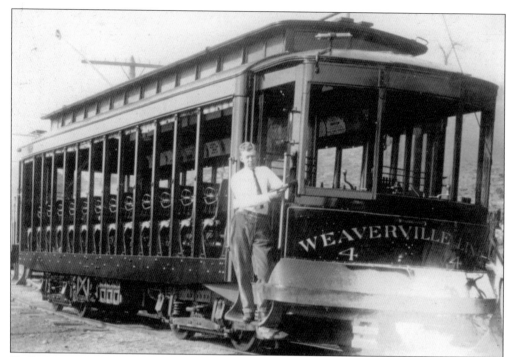

Trolleys were a popular form of transportation in the late 1800s and early 1900s. Asheville's trolley system was growing, so Rex Howland established a trolley line from Weaverville to Asheville. The first car rolled into Pack Square from Weaverville on Saturday, September 4, 1909. The line prospered for a time, but financial troubles plagued it. A 1922 fatal head-on collision signaled the trolley's demise. The line shut down on November 29, 1922.

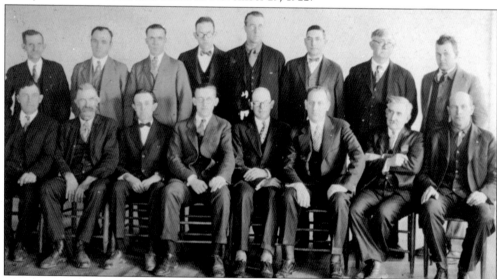

These are members of the Hamburg Lodge, a unit of the Independent Order of Odd Fellows. Shown here are, from left to right, (first row) C.E. Roberts, W.L. Parker, Fred Garrison, E.M. Reagan, M.F. Yost, H.G. Reagan, J.N. Gill, and J.W. Phipps; (second row) J.J. Reagan, J.D. Cranford, Arthur Black, William Yost, R.B. Watts, Glen West, J.E. Murdock, and P.T. Pickens Jr. (Courtesy of Gary and Vicki West, West Family Funeral Services.)

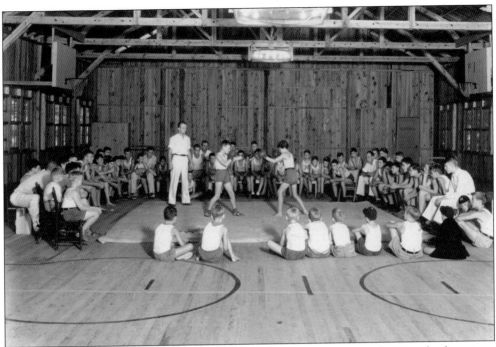

Weaverville children were regulars at Camp Mount Mitchell. These 1932 photographs show some of the local kids learning new skills at the camp. (Courtesy of Larry T. Sprinkle.)

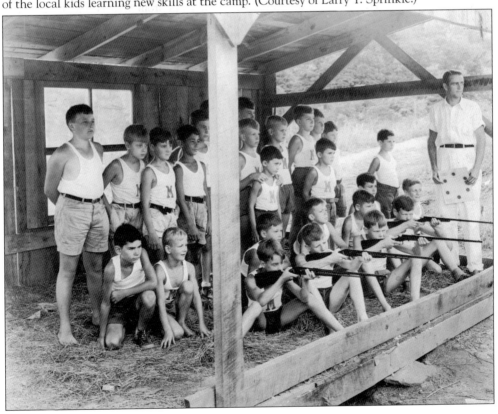

Sherman (1865–1945) and Althea West (1865–1947), parents of Dora West, show that the horse and buggy was in style in downtown Weaverville for a number of years. They are turning from Alabama Avenue into the West Funeral Home lot, very probably returning from church at what was then Weaverville Baptist Church, now First Baptist Church Weaverville. (Courtesy of Gary and Vicki West, West Family Funeral Services.)

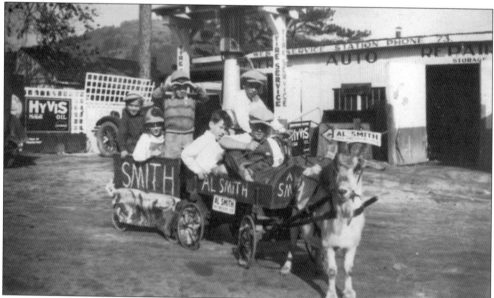

In 1928, Pres. Calvin Coolidge, a Republican, decided against running for reelection. The Republicans nominated Herbert Hoover from California to represent their party, while the Democrats put forth New Yorker Al Smith. This photograph, taken at the West Service Station, shows that Smith had some Weaverville support—at least among the kids. Unfortunately for the New Yorker, not enough adults supported him, and he lost to Hoover in the electoral college 444-87. (Courtesy of Gary and Vicki West, West Family Funeral Services.)

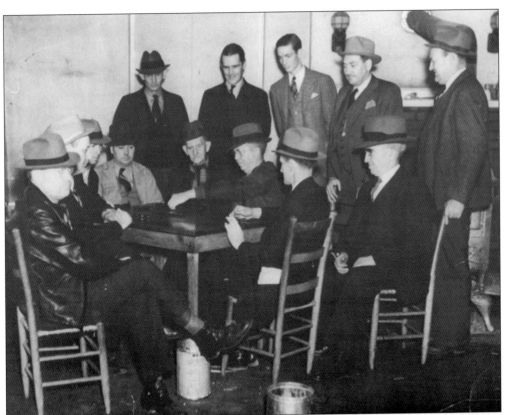

Service stations, like barber shops, were more than just places of business. They were social centers for the local men. Here, some Weaverville residents engage in a game of dominos at the West Service Station. (Courtesy of Gary and Vicki West, West Family Funeral Services.)

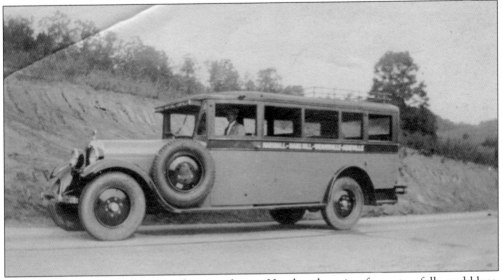

Malcolm Holcombe was a musical artist of note. He played a mix of country, folk, and blues. His father and grandfather ran the Holcombe Bus Line, which was most known for providing transportation between Weaverville and Mars Hill, though it had varied routes over the years.

Though the Holcombe Bus Line has long been defunct, the building that housed the Holcombe garage still stands on Central Avenue near the intersection with Merrimon Avenue. It was later used as a fire station for the Town of Weaverville. Standing in front of the old bus garage are Marshall J. "Buster" West (left), Marion Jerome Holcombe (center), and Charles Glen West Jr. (Courtesy of Gary and Vicki West, West Family Funeral Services.)

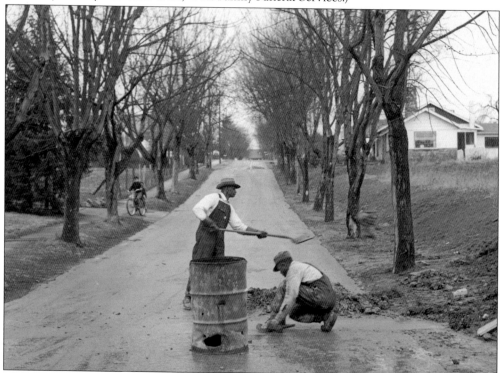

The increasing numbers of paved streets and cars meant more street repair. These two men are making repairs on Alabama Avenue, roughly in front of what is today the Alan Shepard home. (Courtesy of Gary and Vicki West, West Family Funeral Services.)

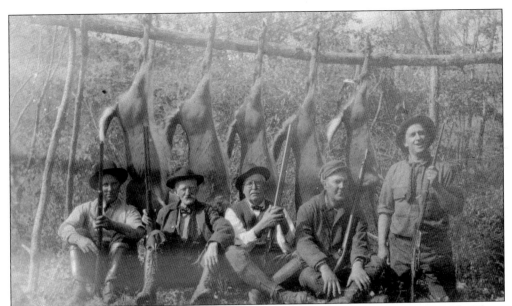

Hunting was a common activity, engaged for leisure and to help put food on the table. These Weaverville-area men proudly exhibit the results of a productive day.

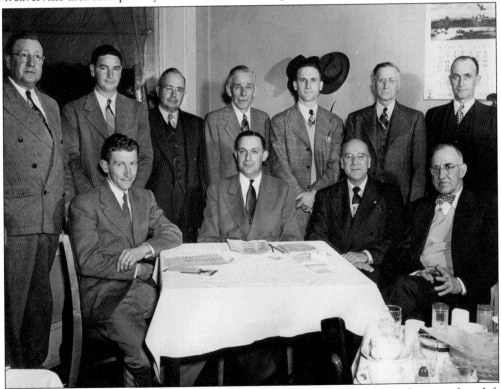

Officers of the Lions Club gather for a photograph on March 25, 1949. Shown here are, from left to right, (first row) June Parks Jr., R.A. Tomberlin, W.A. Rich, and Dr. J.C. Bradley; (second row) E.L. Loftin, Marshall West, Grover C. Brown, Gen. G.I. Rowe, Lawrence T. Sprinkle, John A. Reagan, and Paul Brown. (Courtesy of Larry T. Sprinkle.)

By the 1930s and 1940s, a car culture was already growing among guys. A young Lawrence Tilson Sprinkle Sr. is on the right in this photograph. The other persons shown here are not identified. (Courtesy of Larry T. Sprinkle.)

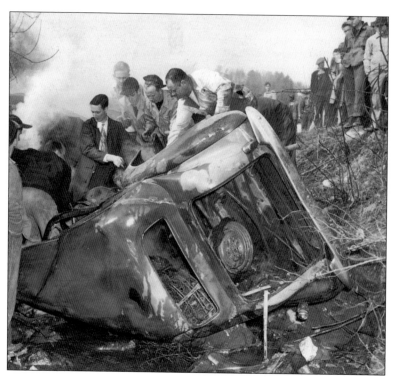

With cars came car wrecks. This substantial accident in Weaverville drew quite a crowd of onlookers. (Courtesy of Gary and Vicki West, West Family Funeral Services.)

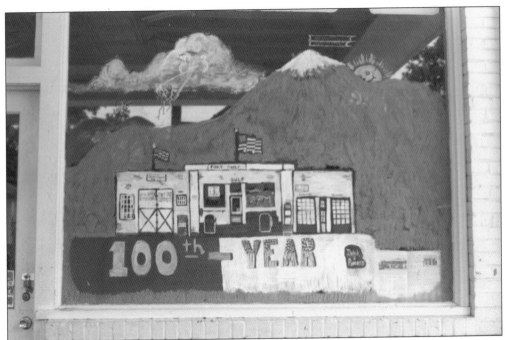

Weaverville was recognized as a town in 1875, and a major centennial celebration was held in 1975. A parade on Main Street marked the occasion on August 9. A centennial program started that day at 2:30 p.m. at the First Baptist Church. (Courtesy of Larry T. Sprinkle.)

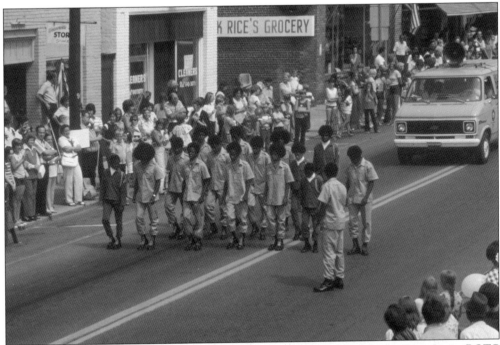

This group of young men in the 1975 centennial parade represented the Marine Corps Junior ROTC from Asheville High School, which was integrated in 1970. (Courtesy of Larry T. Sprinkle.)

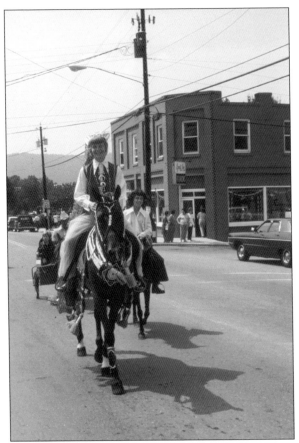

The August 10, 1975, edition of the *Asheville Citizen-Times* reported on the centennial activities: "Weaverville celebrated its first hundred years with the biggest day in its history on Saturday. There was a milelong parade through streets lined with hundreds of people. Then came visits to colorful booths in the municipal parking lot. A patriotic rally was held in the afternoon and finally a time for fun, dancing until the late hours." (Courtesy of Larry T. Sprinkle.)

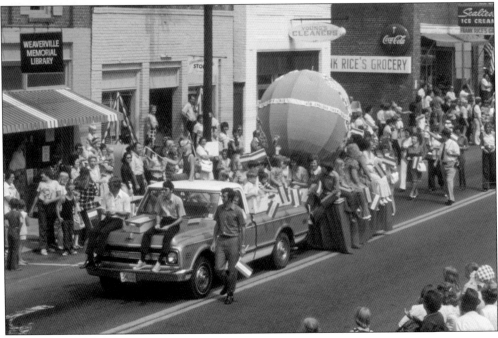

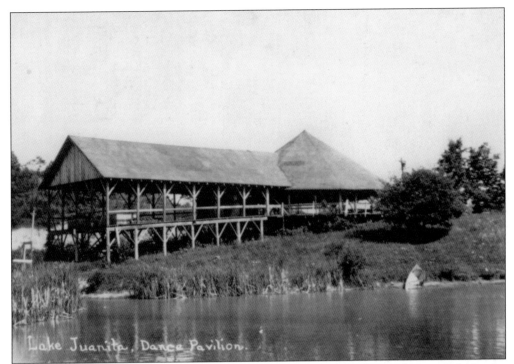

Lake Juanita, Dance Pavilion.

Initially called Lake Juanita and featuring this grand dance pavilion, this site became Lake Louise in 1921 and was bought by the town in 1936. It is now one of Weaverville's main leisure spots, featuring playground facilities, picnic tables, a fitness area, and a walking path.

Lake Louise has long been a well-recognized area for leisure activities in Weaverville. (Courtesy of Gary and Vicki West, West Family Funeral Services.)

A major effort to clean up Lake Louise came about in 1976, headed by the Weaverville Jaycees. (Both, courtesy of Larry T. Sprinkle.)

The area was then extensively renovated and improved in 1987 to become what it is today. (Courtesy of Larry T. Sprinkle.)

Lake Louise was overgrown with lily pads before the Weaverville Jaycees initiated a major cleanup in 1976. (Courtesy of Larry T. Sprinkle.)

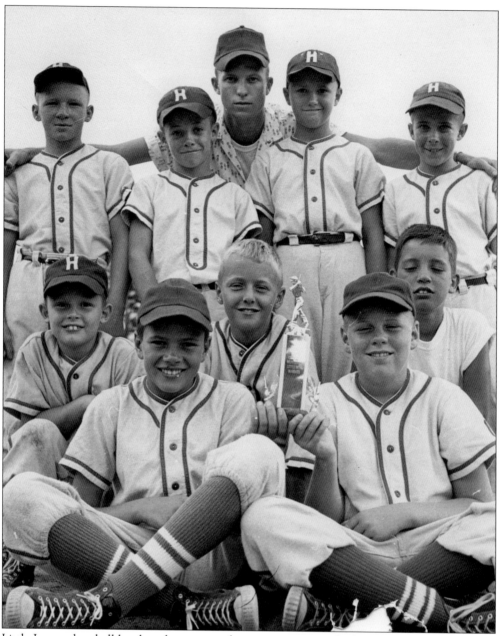

Little League baseball has long been a popular summer activity for local boys. This team, from the late 1960s, was sponsored by the Hadley Corporation. (Courtesy of Larry T. Sprinkle.)

Seven

FLAT CREEK
AND REEMS CREEK

When residents talk about Weaverville or say that they "live in Weaverville," often they are referring to the areas of Flat Creek and Reems Creek. These communities are beyond Weaverville's city limits, but they have Weaverville postal addresses. At one time, these areas were dotted with post offices, schools, and churches, but they are now considered to be part of one overall community.

Perhaps Flat Creek's biggest claim to fame over the years was that it was home to the Asheville-Weaverville Speedway. Indeed, the racetrack with both Asheville and Weaverville in its name was not located at either place. It was in Flat Creek. In fact, the site of the long-defunct racetrack is now home to North Buncombe High School.

Reems Creek, on the other hand, is known as one of the oldest areas settled by Europeans in Western North Carolina. The area was home to the Vance family and is still the location of the Vance Birthplace State Historic Site. Zebulon Baird Vance, the third of eight children of David and Mira Baird Vance, was born on this property in 1830. He was elected to the North Carolina House of Commons at age 24 and then to the US House of Representatives in 1858. When the Civil War began, Vance, who had been a staunch Unionist, became commander of the 26th North Carolina Regiment, fighting for the Confederacy. In 1862, at 32 years of age, he was elected governor of North Carolina. After the war, he was elected to the US Senate, but the Republicans in charge refused to seat him due to his Confederate ties. Instead, he was reelected governor. In 1879, he was elected and seated into the US Senate. He served three terms in the Senate and was just beginning a fourth term when he died in 1894. He is buried a few miles away in Asheville's Riverside Cemetery.

As for the name Reems Creek, it can be found in early records and on various maps as Rims or Reams. In fact, natives of the area know that the proper pronunciation is indeed "rims." The story of the name is not particularly romantic. As legend has it, a man with the last name Rims was killed by Indians along the creek. Somehow he got the creek named after him.

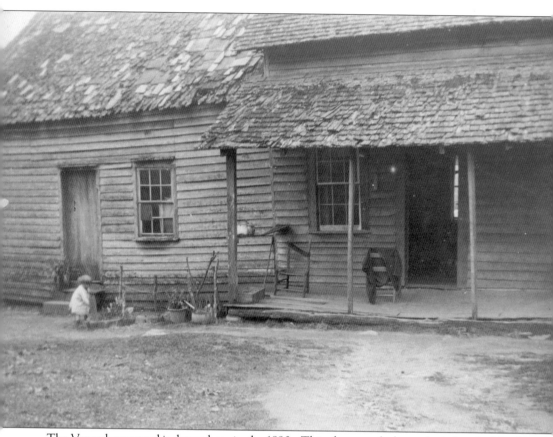

The Vance homestead is shown here in the 1890s. This photograph shows the left end of the front porch and the front side of the kitchen. By this time, the house was already about 100 years old. What now stands as the birthplace of Zebulon Baird Vance is a reconstruction of the original house, built around its original (1795) chimney. (Courtesy of Pack Memorial Library.)

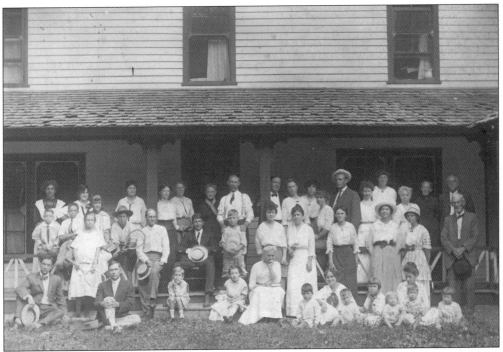

A family gathers outside a house at Dula Springs around 1911. Those identified include Charles Chambers (center, with tie), Sallie E. Dillworth (in dark dress beside Chambers), and William J. Cocke Sr. (to the right of the center pole). (Courtesy of Pack Memorial Public Library.)

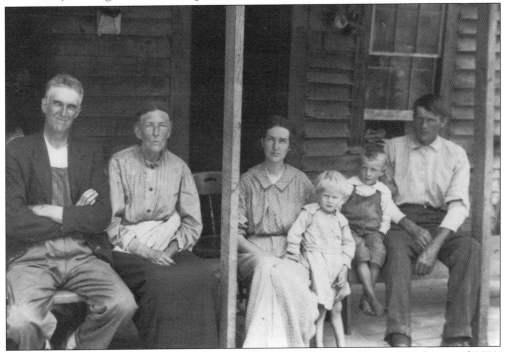

Here is a family of probably three generations on a front porch in Reems Creek around 1916. (Photograph by William A. Barnhill; courtesy of Pack Memorial Public Library.)

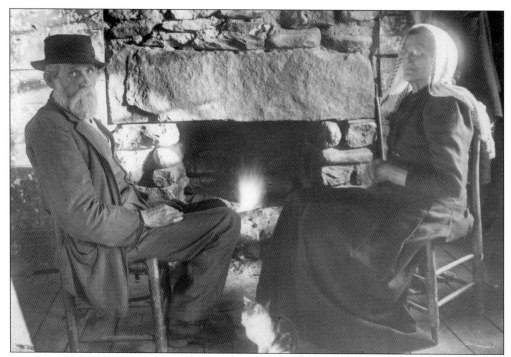

This unidentified couple sits by the fireplace in their home along Reems Creek near Beech. Note the cat sitting near their feet. (Photograph by William A. Barnhill; courtesy of Pack Memorial Public Library.)

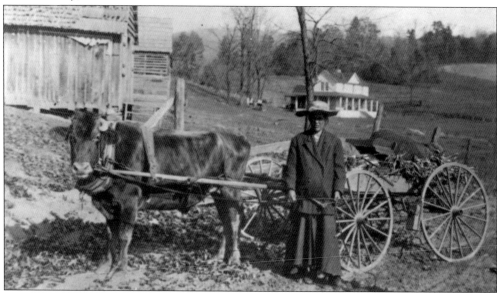

This is a c. 1915 photograph of an unidentified woman leading an ox-drawn wagon loaded for a trip to the market. The house in the background belonged to George Donkel (1870–1940), a noted potter. Along with his brother David and mother, Maggie Hill, Donkel operated Reems Creek Pottery. Their shop, built of logs and lumber, stood on the north side of Reems Creek Road, burrowed into the side of a dugout hill. (Photograph by William A. Barnhill; courtesy of Pack Memorial Public Library.)

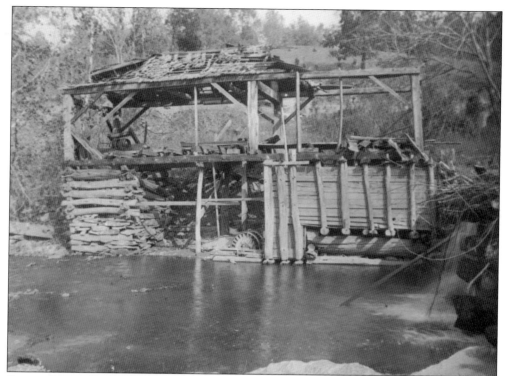

Some of the mills along Reems Creek were gristmills; others were sawmills. This photograph depicts the ruins of an old sawmill on Reems Creek. (Photograph by William A. Barnhill; courtesy of Pack Memorial Library.)

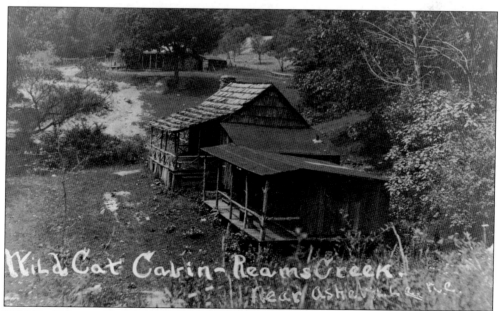

Wild Cat Cabin stood near the Blackberry Inn, near the family cabin of Simeon and Lucy Ramsey at the head of Reems Creek. (Courtesy of Pack Memorial Public Library.)

Zebulon Baird Vance's birthplace had fallen into disrepair by the 1950s, when this photograph was taken. The property became the Vance Birthplace Historic Site, with a new house reconstructed around the old chimney. The site, open to the public, hosts annual living-history programs and is a popular site for school field trips. (Courtesy of the State Archives of North Carolina.)

This photograph of Zebulon Vance's birthplace dates to August 20, 1955, when the house had already fallen into disrepair. Fortunately, an effort was made to save the homestead. While this building no longer stands, a re-creation of it has been erected, along with several other outbuildings. The site allows visitors to get a glimpse of life in the late 1700s and early 1800s. (Courtesy of the State Archives of North Carolina.)

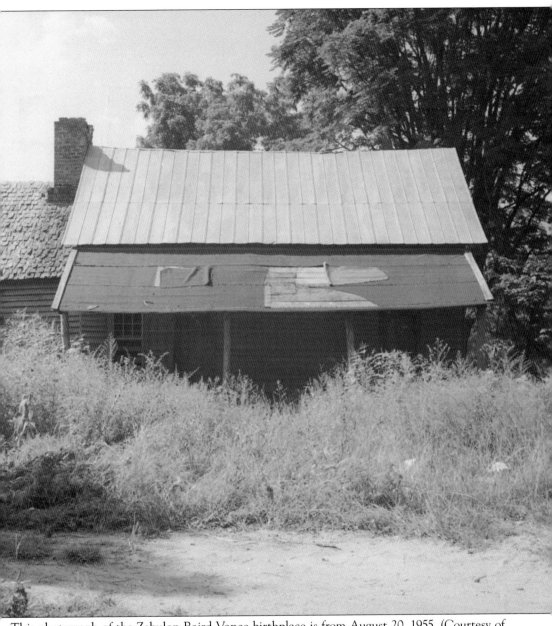

This photograph of the Zebulon Baird Vance birthplace is from August 20, 1955. (Courtesy of the State Archives of North Carolina.)

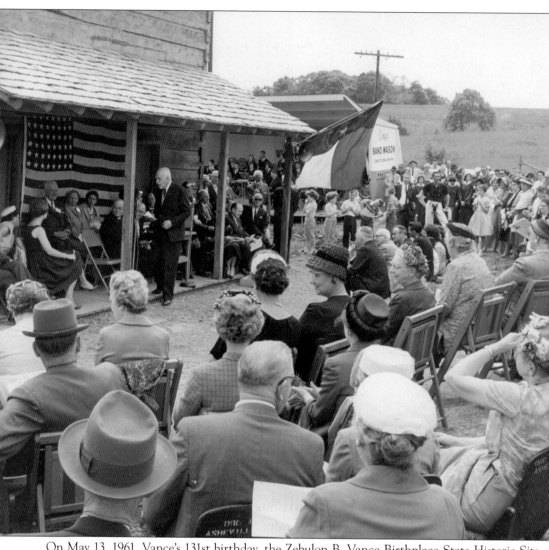

On May 13, 1961, Vance's 131st birthday, the Zebulon B. Vance Birthplace State Historic Site was dedicated and opened to the public. It is located at 911 Reems Creek Road, just a few miles outside of Weaverville. (Photography by Lou Harshaw; Courtesy of Pack Memorial Library.)

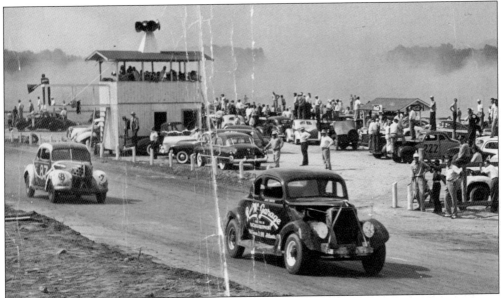

One of Flat Creek's biggest claims to fame was actually not known by the town's name. The Asheville-Weaverville Speedway was located where North Buncombe High School is today. It was a regular stop on the early NASCAR circuit. (Courtesy of Gary and Vicki West, West Family Funeral Services.)

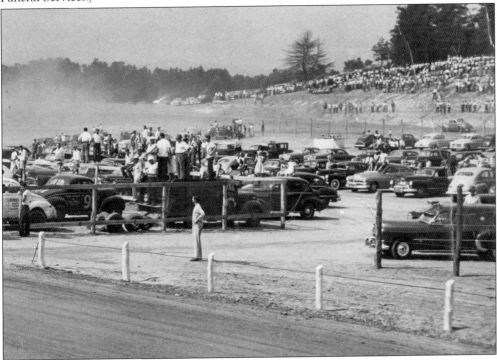

The Asheville-Weaverville Speedway was dominated in its early days by the Flock brothers. Fonty Flock won the first NASCAR race at the track in 1951, and he won again in 1953. His brother Bob won in 1952, and brother Tim won in 1955. (Courtesy of Gary and Vicki West, West Family Funeral Services.)

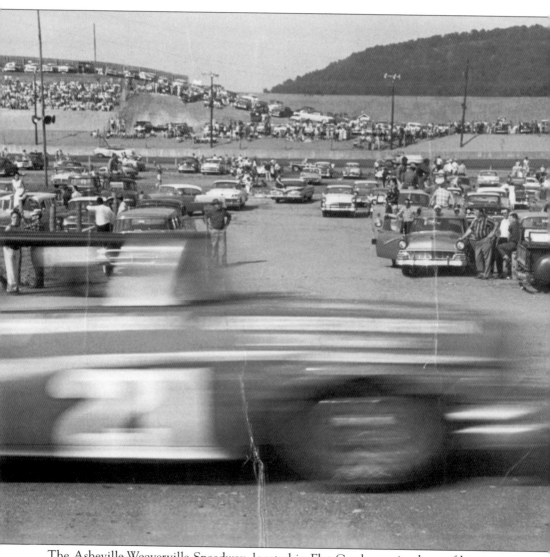

The Asheville-Weaverville Speedway, located in Flat Creek, saw its share of big-time racing names in the winner's circle, including Lee and Richard Petty, Fireball Roberts, Rex White, Junior Johnson, Ned Jarrett, Bobby Allison, and David Pearson. The last NASCAR race at the track took place in 1969. (Courtesy of Gary and Vicki West, West Family Funeral Services.)

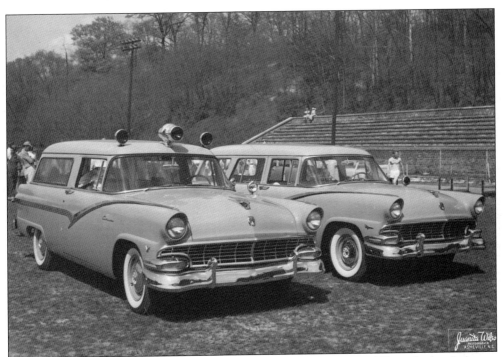

In the days of the old Asheville-Weaverville Speedway, the West Funeral Home had ambulances ready to roll in case of a medical emergency. (Courtesy of Gary and Vicki West, West Family Funeral Services.)

Buildings for the set of the movie *Songcatcher* were erected near the old Blackberry Inn, off Reems Creek Road. (Courtesy of Pack Memorial Public Library.)

DISCOVER THOUSANDS OF LOCAL HISTORY BOOKS
FEATURING MILLIONS OF VINTAGE IMAGES

Arcadia Publishing, the leading local history publisher in the United States, is committed to making history accessible and meaningful through publishing books that celebrate and preserve the heritage of America's people and places.

Find more books like this at
www.arcadiapublishing.com

Search for your hometown history, your old stomping grounds, and even your favorite sports team.